Me

Sir Joshua Reynolds

MEMOIRS OF
SIR JOSHUA REYNOLDS

BY

JOSEPH FARINGTON

with an introduction by
MARTIN POSTLE

PALLAS ATHENE

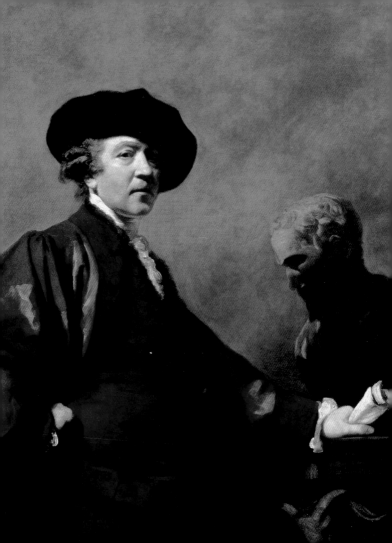

INTRODUCTION

MARTIN POSTLE

On the night of 2 March 1792 Joshua Reynolds' funeral bier rested in the Royal Academy at Somerset House, on London's Strand. The room, normally used by students to draw from the living model, was draped in black, lit by candles mounted in silver sconces. The following afternoon, Reynolds' body was conveyed from Somerset House for state burial in the crypt of St. Paul's Cathedral. The cortège, which stretched nearly two miles, consisted of ninety-one carriages. The artist's pall-bearers numbered three dukes, two marquises, three earls, a viscount and a baron. At his death, Sir Joshua Reynolds, first President of the Royal Academy, author of the Discourses on Art, *Principal Painter to the King, Honorary Doctor of Civil Law at the University of Oxford, and Mayor of Plympton, was among the most celebrated artists in Europe.*

In the years leading up to his death Reynolds was

Opposite: Self-portrait with Bust of Michelangelo, c. 1779-80

determined that his name should be passed down to posterity. He planned his own burial in St Paul's; he even saw to it that a statue to him was erected in the cathedral. He was also concerned about his biography. In the 1780's he had hoped that his close ally James Boswell, the author of the great biography of their mutual friend, Samuel Johnson, would undertake the task. In the event, Boswell declined. Reynolds' first biographer was another friend, the Shakespeare scholar Edmond Malone, who prefixed his edition of Reynolds' Literary Works of 1797 with an essay on his life. Malone had known Reynolds intimately, and was well placed to write his biography, although, as he admitted, he was not qualified to comment upon his art. In due course a more extensive biography was published by Reynolds' pupil, James Northcote, whose Memoirs of Sir Joshua Reynolds Knt. first appeared in 1813, and in an expanded two-volume edition in 1818. This biography, although it remains an essential first-hand account of Reynolds' life and art, was essentially a piece of hackwork, cobbled together from Northcote's reminiscences and clippings from contemporary newspaper articles, which were included verbatim.

In 1819 the artist Joseph Farington published his own biography of Reynolds. The least well known of Reynolds' biographies, it nonetheless contains some of the most fascinating first-hand insights into the artist's career and

achievements. Farington, born in 1747 in Manchester, trained in London as a landscape painter under the Welsh artist Richard Wilson. While he was not particularly gifted as a landscapist (see p. 29), Farington was very active in the affairs of the Royal Academy of Arts, to which he was elected in 1785. From 1793 until his death in 1821 Farington kept a detailed diary in which he meticulously recorded artistic, literary and political gossip. This diary, eventually published in its entirety between 1978 and 1984, is one of the most important documents on British art in Georgian England. Although Farington had not known Reynolds well, he had observed him acutely at the Academy, and was close to a number of his professional associates. These included his studio assistant, Giuseppe Marchi (c. 1735-1808), who as a teenager had accompanied Reynolds from Italy to England in 1752, and who provided Farington with so many unique insights into Reynolds' professional life.

Joshua Reynolds was born on 16 July 1723 in Plympton, Devon, where his father was employed as vicar and master of the local grammar school. Taught by his father, Reynolds at first toyed with becoming a pharmacist, stating that he would rather be 'an apothecary than an ordinary painter'. As it was, he decided to serve an apprenticeship with the Devonian portrait painter, Thomas Hudson (1701-1779). Hudson may not have been

a painter of great distinction, but he was certainly not the 'imbecile' that Farington makes out. And while Reynolds and Hudson did, as Farington affirms, fall out with one another briefly in the early 1740's, they soon patched up their quarrel. Indeed, Hudson made a point of introducing Reynolds to his exclusive collectors' club, the members of which shared a passion for Old Master drawings and engravings. From the mid-1740's Reynolds practised independently as a portrait painter, working in London and in his native Devon. While many of his portraits were routine commissions of naval officers and local gentry, Reynolds also produced several works of brilliance, including Captain John Hamilton (Duke of Abercorn, 1746; see p. 40), an extraordinary bravura performance in the manner of Titian. Around 1748 he also painted a remarkable Rembrandtesque self-portrait (National Portrait Gallery), in which he shades his eyes dramatically with his hand, as he looks confidently towards his bright future.

In 1749 Reynolds sailed to Italy, gaining a free passage on board a ship commanded by Commodore Augustus Keppel, younger son of the Earl of Albemarle and destined to become a lifelong friend of the artist. Reynolds spent three years in Italy, based largely in Rome, with excursions to other major artistic cities, including Florence, Naples, Venice and Bologna. What Reynolds

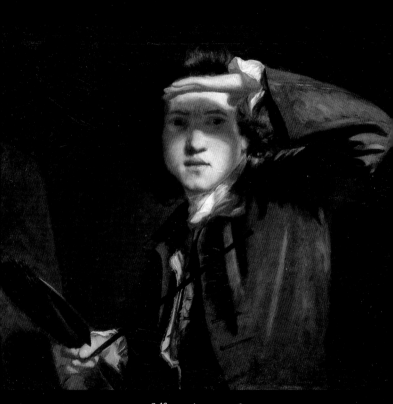

Self-portrait c. 1747-48

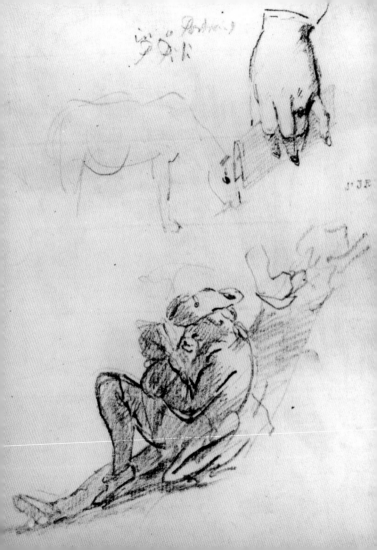

lacked in experience and innate ability he made up for in his desire to absorb the example of the old masters. 'He had,' as Farington stated, 'much to learn, but nothing to unlearn.' Reynolds painted relatively little while he was abroad, save for a handful of portraits and a few copies. Instead he filled sketchbooks with notes and rapid studies, from which he drew inspiration in years to come. Aside from outlining Reynolds' itinerary on the continent, Farington provides some fascinating details of the journey, including his surprise encounter with Hudson in the Alps, and Marchi's enforced tramp from Lyons to Paris, when Reynolds ran short of funds to finance his youthful travelling companion.

On his return to England in 1752, Reynolds painted Giuseppe Marchi in an exotic fur-trimmed coat and turban (Royal Academy of Arts; see p. 59) – a portrait which, according to Farington, was severely criticized by Hudson. He also, at this time, produced the magnificent full-length portrait of Augustus Keppel (National Martime Museum; see p. 60), striding along a windswept coastline, the pose based upon a statue of the classical god,

Opposite: Sheet of sketches from a notebook used by Reynolds on his Italian trip. From top to bottom: a woman's hand holding a letter, from a late Renaissance or early Baroque painting; a horse grazing, perhaps from life; an artist sketching in the open air

Apollo, and the rich colour upon the art of the Venetian painter Tintoretto. During the 1750's Reynolds' portrait business expanded rapidly, requiring him to employ, in addition to Marchi, various other pupils and assistants. These individuals, men such as Peter Toms and Thomas Beach, prepared his canvasses, painted costumes and accessories, and even replicated his works. Inevitably, Reynolds' prolific rate of production resulted in lapses in quality, as did his incessant experimentation with painting materials. As Farington observes, Reynolds often experimented with colours, his use of 'fugitive' reds, for example, resulting in the faces of portraits being reduced to a ghostly pallor. He also combined waxes with turpentine and a tarry substance called asphaltum, which gave rise to unstable and disfigured paint surfaces. For all this, Reynolds' success was unquestioned, and he became a rich man. It was at this time too, in the 1750's and 60's, that he developed his unrivalled social and intellectual network. In addition to his skills as a painter, Reynolds was adept at forming relationships with a wide range of celebrated individuals. They included writers such as Samuel Johnson, Oliver Goldsmith, Edward Gibbon and James Boswell, and actors such as David Garrick, whom he portrayed between the muses of Comedy and Tragedy in his witty allegorical portrait of 1762 (see p. 76). Reynolds was intimate with politicians of the calibre of Edmund

Burke, Charles James Fox, and Richard Brinsley Sheridan, all of whose portraits he painted. Reynolds also wooed the aristocracy. And while George III could not bear him, the King's opponents in the Whig party flocked to Reynolds' studio: powerful grandees such as Lord Rockingham (private collection and Fitzwilliam; see p. 115), and the vivacious Duchess of Devonshire (Chatsworth; see overleaf). Later in life, Reynolds attracted the patronage of the younger generation of aristocrats, notably the king's eldest son, George, Prince of Wales, whom he flattered shamelessly in a series of glamorous portraits (see Tate, Lord Lloyd Webber, and Duke of Norfolk – see p. 98).

 In his memoir of Reynolds, Farington, who became something of an éminence grise in the Royal Academy, inevitably paid close attention to the machinations that caused Reynolds to be elected first president in December 1768 – despite the enmity of the King. Indeed, while Reynolds clearly coveted the presidency he shrewdly 'left it to others who were better situated' to obtain the King's patronage. Once he had gained control of the Academy, and a knighthood from the King, Reynolds used his position to enhance the status of British art. This he did by

Overleaf: Georgiana, Duchess of Devonshire and her daughter, Lady Georgiana Cavendish, 1784

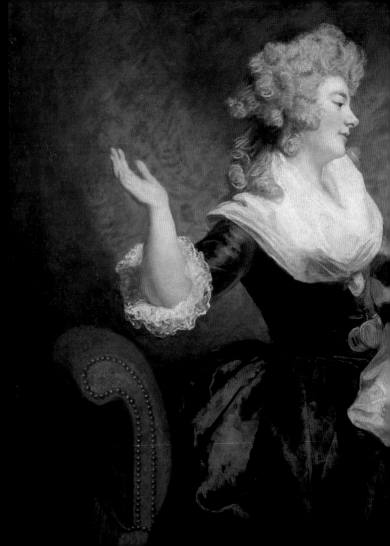

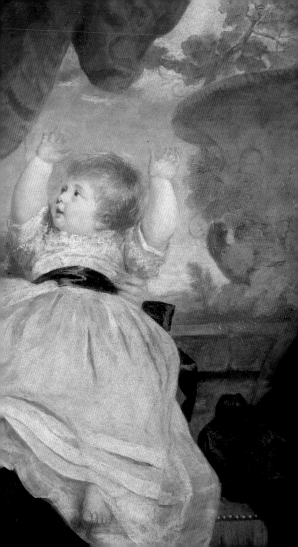

ting vigorously to the annual summer exhibition;
ough the publication of his lectures on artistic
, the Discourses on Art. Reynolds' fifteen dis-
delivered to the Royal Academy between 1769
o, represented the most significant body of art
to have appeared in the English language; they
d his reflections on art, as well as core concepts
fame, genius, originality, and invention. Indeed,
's Discourses formed just one of a series of paral-
urses on the arts written by his friends, including
Burney's History of Music, Thomas Warton's
of English Poetry and Johnson's Lives of the
Poets. Through his position at the Royal
y Reynolds promoted himself as an arbiter of
istinguished not only for his intellect but also,
g to Farington, for 'his exemplary moral con-
s Farington recalled, Reynolds' presidency coin-
ith an improvement in social behaviour, not least
the artistic community, where gentlemanly con-
s encouraged.

ng the 1770's and 1780's Reynolds exhibited
ely at the Royal Academy's annual exhibitions, to

te: Mrs. Thrale and her daughter Hester, nicknamed Queeney.
le was the centre of a literary circle that included Johnson and
The portraits on pages 31 and 111 were painted for the library
usband's house, Streatham Park, and this painting was to have
been over the fireplace, but Mrs. Thrale disliked it

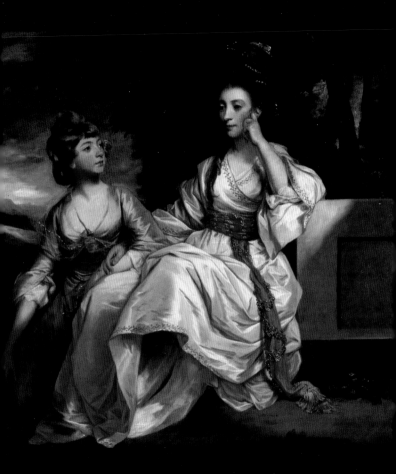

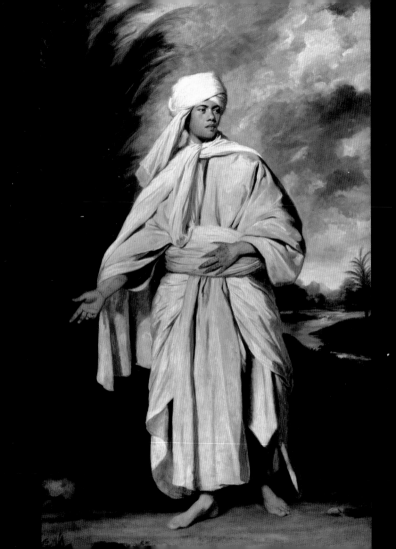

which he contributed over 140 works. They included some of his greatest portraits. In 1776 he exhibited a portrait of Omai (private collection), the first Polynesian to visit England. In Reynolds' portrait Omai is presented in flowing white robes as a regal figure, endowed with natural grace and nobility. Two years later Reynolds showed his ambitious dynastic portrait of the Marlborough Family (Blenheim Palace), which combined baroque swagger with playful intimacy. Reynolds also at this time branched out into history painting. In 1773 he exhibited Ugolino and his Children in the Dungeon *(Knole; see p. 144), based upon Dante's* Inferno, *a work that was to prove influential on a younger generation of history painters both in England and in France. Reynolds also began to produce allegorical character studies of children, which contemporaries referred to as 'fancy pictures'. They included infant saints, and classical deities, such as* Cupid as a Link Boy *(Albright-Knox Art Gallery, Buffalo, New York, c.1773) and the* Age of Innocence *(Tate, c. 1785). These pictures proved highly popular both during Reynolds' lifetime and in the Victorian era, the* Age of Innocence *being replicated by copyists over 300 times when it belonged to the National Gallery in the second half of the 19th century.*

Opposite: Omai, c. 1775-1776

Throughout his life Reynolds was dedicated to the work ethic. While he socialized freely in the evenings, attending balls, dinners, and masquerades, his days, including Sundays, were spent in the studio. From the autumn to the following mid-summer he painted portraits, while in the month of August he concentrated upon his subject pictures. During the 1780's he attracted patrons from abroad as well as at home, notably the Russian Empress, Catherine the Great, for whom he painted a large allegorical picture, Hercules Strangling the Serpents *(Hermitage, St Petersburg, 1788). Although he had visited the continent infrequently since his Italian sojourn, in the summer of 1781 he made a visit to Flanders and the Low Countries, where he studied intently the art of Rembrandt, Van Dyck, and Rubens, whose use of vivid colour he instinctively admired. Reynolds also collected prominent examples of these artists' work, together with paintings by masters of the Italian, French and German schools. These pictures he exhibited alongside his own in the picture gallery adjoining his house in Leicester Square, forming one of the finest art collections in the capital.*

As Farington intimates, Reynolds' final years as

Opposite: Charles, 3rd Duke of Richmond, c. 1758; the pose is taken from Van Dyck, but the vivid colour owes more to Rubens

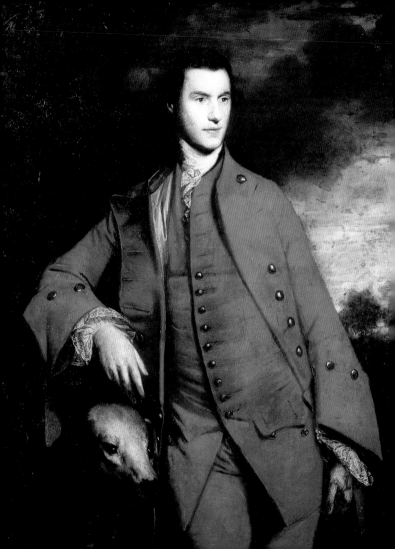

President of the Royal Academy were marked by internecine strife. A number of prominent painters, notably Thomas Gainsborough, seceded from the Academy's annual exhibition, while others in the rank and file opposed Reynolds' increasingly autocratic manner. This emerged notably over what became known as the 'Bonomi affair', in which Reynolds' promotion of the career of the Italian draughtsman, Joseph Bonomi, resulted in his temporary resignation as President. Farington, who was to become one of the staunchest guardians of Reynolds' posthumous reputation, led the opposition against him in this instance, as he records in the Memoir. *Although Reynolds resumed the presidency in the spring of 1790, he was by now in poor health, suffering from loss of sight caused by an undiagnosed malignant tumour of the liver. His final appearance at the Academy, as Farington records, was on 25 June 1791. He died the following February, aged sixty-eight. Farington, who attended Reynolds' funeral, recorded the pomp and ceremony that accompanied the event in minute detail. 'Thus,' he concluded, 'were deposited the venerable relics of Sir Joshua Reynolds, doubly hallowed by a nation's*

Opposite: Mary, Duchess of Richmond, c. 1764-67. In striking contrast to the portrait of her husband (p. 21), this painting shows Reynolds' mastery of the intimate

respect, and by the tears of private friendship'.

Joseph Farington's Memoirs of Sir Joshua Reynolds remains an invaluable account of Reynolds' professional career and his role in British eighteenth-century art and society. Farington, through his extensive contacts with Reynolds' friends and family, and his privileged position in the Royal Academy, was able to offer unique biographical insights. Throughout his account Farington attempts to offer a fair-minded account of Reynolds's achievement. He readily praises Reynolds' virtues: his capacity for hard work, his versatility as a portraitist, and his pivotal role in the Royal Academy. Farington also acknowledges Reynolds's shortcomings: his lack of academic training, his technical flaws, and his occasional highhandedness. Ultimately, through Farington's first-hand account, we are able to understand more fully why Reynolds was so highly regarded by his peers and why he became to be regarded as the founding father of the British School of Art.

MEMOIRS

OF

THE LIFE

OF

SIR JOSHUA REYNOLDS

WITH

SOME OBSERVATIONS ON HIS TALENTS

AND CHARACTER

BY JOSEPH FARINGTON, R. A.

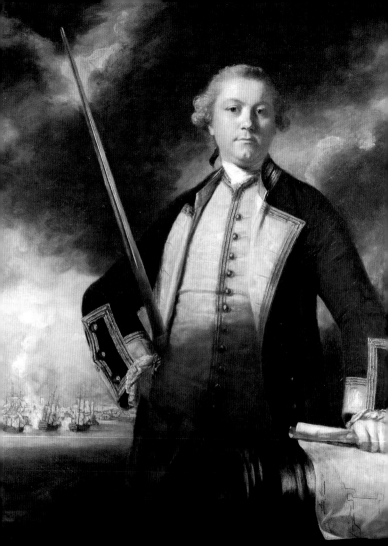

It has often been remarked that there is no reading more amusing and instructive than the detail of the life of an extraordinary man. In the present instance we see how a character, formed by early habits of consideration, self-government, and persevering industry, acquired the highest fame, and made his path through life a course of unruffled moral enjoyment. Sir Joshua Reynolds, when young, wrote rules of conduct for himself. One of his maxims was, 'that the great principle of being happy in this world, is, not to mind or be affected with small things.' To this rule he strictly adhered; and the constant habit of controlling his mind greatly contributed to that evenness of temper which enabled him to live pleasantly with persons of all descriptions. Placability of temper may be said to have been his characteristic. The happiness of possessing such a disposition was acknowledged by his friend Dr. Johnson, who said, 'Reynolds was the most invulnerable man he had ever known.'

The life of this distinguished Artist exhibits a useful lesson to all those who may devote themselves to

Opposite: Augustus Hervey, 3rd Earl of Bristol, 1762. One of the many naval heroes painted by Reynolds, he is shown capturing the port of Havana during the Seven Years' War

the same pursuit. He was not of the class of such as
have been held up, or who have esteemed them-
selves to be heaven-born geniuses. He appeared to
think little of such claims. It will be seen in the
account of his progress to the high situation he
attained in his profession, that at no period was
there in him any such fancied inspiration; on the
contrary, every youthful reader of the memoirs of
Sir Joshua Reynolds may feel assured, that his ulti-
mate success will be in proportion to the resolution
with which he follows his example.

Joshua Reynolds was born at Plympton, in
Devonshire, July 16th, 1723. He was son of the Rev.
Samuel Reynolds and Theophila, his wife, whose
maiden name was Potter. He was the seventh of
eleven children, five of whom died in their infancy.
His godfathers were his uncle Joshua, Mr. Aldwin
being his proxy, and Mr. Ivie. His godmother was his
aunt Reynolds of Exeter, Mrs. Darley proxy. At his
baptism he was named Joshua. Upon the authority
of Dr. Percy, late Bishop of Dromore, Mr. Malone
has given a fanciful account why he was so named.
There seems to be no probable foundation for it. It
was agreeable to common usage for an infant to
be named after one of its sponsors, and it may

Plympton, birthplace of Sir Joshua Reynolds.
Etching by Lititia Byrne after Joseph Farington.
Used as the frontispiece of the
original edition of the Memoirs

naturally be supposed to have been the case in this instance.

Mr. Samuel Reynolds was master of the grammar school at Plympton; and whatever classical instruction Sir Joshua received was under the tuition of his father. Some literary scraps have been published to show that in his youth he was illiterate, and circumstances are mentioned in them which make it probable that they were genuine. They go to prove that, at that period, from 1749 to 1751, when he was twenty-six or twenty-seven years old, his orthography was incorrect, and that he was careless in the composition of his letters. What he really gained while instructed by his father cannot now be known. But if he made little progress in classical attainment in his youthful days, it is a high proof of his inherent ability, and that, after he became occupied by unceasing exertions in his art, he still found time to make up for youthful negligence, and to obtain so large a proportion of general literary knowledge as to be fitted for the society of men conspicuously distinguished for their superior intelligence. Reynolds could never be considered a scholar, but, living in the best society, and availing himself of every opportunity to cultivate his mind by

study, he was, by the time he arrived at the middle period of life, qualified to commence a course of Lectures on his art, which prove him to have made extraordinary proficiency in literary composition.

For a considerable time after his Discourses delivered at the Royal Academy were published, many attempts were made to deny him the honour of being the author of these compositions. His intimacy with Dr. Johnson, and Mr. Burke, and other eminent literary characters, was universally known; and it was asserted by many persons, from time to time, that though he gave the matter, it was formed for public reading by one or other of those eminent men. This was denied by them, and declared to be a supposition utterly unfounded. Indeed, there are competent judges now living, who well remember, that when required to exert his colloquial powers, he spoke as well as he wrote, and clearly showed his ability for either purpose.

With respect to his early indications of talent for the art, he afterwards professed, it would be idle to dwell upon them as manifesting any thing more than is common among boys of his age. As an amusement he probably preferred drawing to any other to which

he was tempted. In the specimens which have been preserved, there is no sign of premature ingenuity; his history is, in this respect, like what might be written of very many other artists, perhaps of artists in general. His attempts were applauded by kind and sanguine friends, and this encouraged him to persevere till it became a fixed desire in him to make further proficiency, and continually to request that it might be his profession. It is said, that his purpose was determined by reading Richardson's *Treatise on Painting*. Possibly it might have been so: his thoughts having been previously occupied with the subject. Dr. Johnson, in his *Life of Cowley*, writes as follows: 'In the windows of his mother's apartment lay Spenser's *Fairy Queen*, in which he very early took delight to read, till, by feeling the charms of verse, he became, as he relates, irrecoverably a Poet. Such are the accidents which, sometimes remembered, and perhaps sometimes forgotten, produce that peculiar designation of mind, and propensity for some certain science or employment, which is commonly called Genius. The true genius is a man of large general powers accidentally determined to some particular direction. Sir Joshua Reynolds, the great Painter of the present age, had the first fondness for his art excited by the perusal of Richardson's

Treatise.' In this definition of genius Reynolds fully concurred with Dr. Johnson, and he was himself an instance in proof of its truth. He had a sound natural capacity, and by observation and long-continued labour, always discriminating with judgment, he obtained universal applause, and established his claim to be ranked amongst those to whom the highest praise is due; for his productions exhibited perfect originality. No artist ever consulted the works of eminent predecessors more than did Sir Joshua Reynolds. He drew from every possible source something which might improve his practice, and he resolved the whole of what he saw in nature, and found in art, into a union, which made his pictures a singular display of grace, truth, beauty, and richness.

It was the lot of Sir Joshua Reynolds to be destined to pursue the art of painting at a period when the extraordinary effort he made came with all the force and effect of novelty. He appeared at a time when the Art was at its lowest ebb. What might be called an English school had never been formed. All that Englishmen had done, was to copy, and endeavour to imitate, the works of eminent men who were drawn to England from other countries, by encouragement, which there was no inducement to bestow

upon the inferior efforts of the natives of this island. In the reign of Queen Elizabeth, Federico Zuccaro, an Italian, was much employed in England, as had been Hans Holbein, a native of Basle, in a former reign. Charles the First gave great employment to Rubens and Vandyke. They were succeeded by Sir Peter Lely, a native of Soest in Westphalia; and Sir Godfrey Kneller came from Lübeck to be, for a while, Lely's competitor; and after his death, he may be said to have had the whole command of the art in England. He was succeeded by Richardson, the first English painter that stood at the head of portrait painting in this country. Richardson had merit in his profession, but not of a high order; and it was remarkable, that a man who thought so well on the subject of art, and, more especially, who practised so long, should not have been able to do more than is manifested in his works. He died in 1745, aged 80. Jervais, the friend of Pope, was his competitor, but very inferior to him. Sir James Thornhill, also, was contemporary with Richardson, and painted portraits, but his reputation was founded upon his historical and allegorical compositions. In St. Paul's Cathedral, in the Hospital at Greenwich, and at Hampton Court, his principal works are to be seen. As Richardson in portraits, so Thornhill, in history

painting, was the first native of this island who stood pre-eminent in the line of art he pursued at the period of his practice. He died in 1732, aged 56.

The Honourable Horace Walpole, in his *Anecdotes of Painting*, observes, 'that at the accession of George the First, the Arts were sunk to the lowest state in Britain.' This was not strictly true. Mr. Walpole, who published at a later time, should have dated the period of their utmost degradation to have been in the middle of the last century, when the names of Hudson and Hayman were predominant. It is true, Hogarth was then well known to the public; but he was less so as a painter than an engraver, though many of his pictures representing subjects of humour and character are excellent; and Hayman, as a history painter, could not be compared with Sir James Thornhill.

Thomas Hudson was a native of Devonshire. His name will be preserved from his having been the artist to whom Sir Joshua Reynolds was committed for instruction. Hudson was the scholar of Richardson, and married his daughter; and after the death of his father-in-law, succeeded to the chief employment in portrait painting. He was in all

respects much below his master in ability; but being esteemed the best artist of his time, commissions flowed in upon him, and his *business*, as it might truly be termed, was carried on like that of a manufactory. To his ordinary heads, draperies were added by painters who chiefly confined themselves to that line of practice. No time was lost by Hudson in the study of character, or in the search of variety in the position of his figures: a few formal attitudes served as models for all his subjects, and the display of arms and hands, being the more difficult parts, was managed with great economy by all the contrivances of concealment.

To this scene of imbecile performance, Joshua Reynolds was sent by his friends. He arrived in London on the 14th of October 1741, and on the 18th of that month he was introduced to his future preceptor. He was then aged seventeen years and three months. The terms of the agreement were, that, provided Hudson approved him, he was to remain four years: but might be discharged at pleasure. He continued in this situation two years and a half, during which time he drew many heads upon paper, and in his attempts in painting, succeeded so well in a portrait of Hudson's cook, as to excite his master's

jealousy. In this temper of mind, Hudson availed himself of a very trifling circumstance to dismiss him. Having one evening ordered Reynolds to take a picture to Van Haaken the drapery painter; but as the weather proved wet, he postponed carrying it till the next morning. At breakfast, Hudson demanded why he did not take the picture the evening before? Reynolds replied, 'that he delayed it on account of the rain; but that the picture was delivered that morning before Van Haaken rose from bed.' Hudson then said, ' You have not obeyed my orders, and shall not stay in my house.' On this peremptory declaration, Reynolds urged that he might be allowed time to write to his father, who might otherwise think he had committed some great crime. Hudson, though reproached by his own servant for this unreasonable and violent conduct, persisted in his determination; accordingly, Reynolds went that day from Hudson's house, to an uncle who resided in the Temple, and from thence wrote to his father, who, after consulting his neighbour, Lord Edgcumbe, directed him to come down to Devonshire.

Thus did our great Artist commence his professional career. Two remarks may be made upon this event. First, by quitting Hudson at this early period,

he avoided the danger of having his mind and his hand habituated to a mean practice of the art, which, when established, is most difficult to overcome. It has often been observed in the works of artists who thus began their practice, that though they rose to marked distinction, there have been but few who could wholly divest themselves of the bad effects of a long-continued exercise of the eye and the hand in copying ordinary works. In Hudson's school this was fully manifested. Mortimer and Wright of Derby were his pupils. They were both men of superior talents; but in Portraits they never succeeded beyond what would be called mediocre performance. In this line their productions were tasteless and laboured; fortunately, however, they made choice of subjects more congenial with their minds. Mortimer, charmed with the wild spirit of Salvator Rosa, made the exploits of lawless banditti the chief subjects of his pencil, while Wright devoted himself to the study of objects viewed by artificial light, and to the beautiful effects of the moon upon landscape scenery; yet even there, though deserving of great praise, the effects of their early practice were but too apparent: their pictures being uniformly executed with what Artists call 'a heavy hand.'

Secondly, the danger thus escaped by Reynolds could not be known to himself at the time he experienced this ungenerous treatment from Hudson. It must have been to him a serious disappointment. But whatever might be his feelings when it happened, it made no lasting impression on his mind, so as to prevent him from afterwards showing kindness and attention to his old master. That placability of temper which he so eminently possessed, operated in his conduct towards Hudson as long as the jealous and mortified disposition of the latter would allow it.

On his return to Devonshire, being then only in the 20th year of his age, and with no more instruction than has been stated, Reynolds began the regular profession of his Art. The limited circumstances of his father rendered it necessary for him to do what he could for himself. He engaged apartments in the town of Plymouth Dock, and having the patronage of Lord Edgcumbe, and the friendship of many respectable persons, he had sufficient employment. He painted portraits of several naval officers and others,[1] and several years passed while he was thus occupied. Mr. Malone says, that Reynolds often

(1) Various portraits of naval officers and clergymen survive.

spoke of this period as so much time thrown away (so far as it related to a knowledge of the world and of mankind) of which he ever after lamented the loss. This surely must have been misunderstood by Mr. Malone. That he had not an earlier and larger knowledge of the world, was then of little importance to him, as he had undoubtedly sufficient for all useful purposes, especially as he must have associated with the best society that country afforded. But he had real cause to lament the want of a better education in his profession. The basis of all superior Art is ability in drawing the human figure, and knowledge of its anatomy. The valuable days of his youth, the season when it is best, if not alone acquired, passed without his obtaining this, the most essential part of youthful study. The want of this acquirement he felt throughout his life; for, owing to this neglect, he never had professional strength to attempt to execute works which required great power of the hand over form, without exposing his deficiency. In his finest productions, possessing all the splendour of colour, and all the breadth and charm of general effect, imbecility in drawing is manifest, and he was obliged to have recourse to

Opposite: Captain the Hon. John Hamilton (c. 1746), among his most confident early portraits

contrivances to conceal, or slightly to pass over, that which he could not express. Thus limited in professional preparation, he directed the whole force of his mind in the endeavour to carry to perfection that which he could do, and by whatever means he advanced in his Art, it is certain that he did make considerable progress in colouring and effect before he left Devonshire to proceed to Italy.

While he remained in his native country, in addition to his daily study of nature in painting portraits, he had opportunities of seeing the pictures of an artist who possessed much ability. The name of this person was William Gandy. He lived chiefly in Devonshire, and died in the early part of the last century, but was little known beyond the boundary of that county. Mr. Northcote, in his *Memoir of Sir Joshua Reynolds*, gives many particulars respecting him, and mentions that he had often heard Sir Joshua speak of Gandy's portraits with the highest respect; and that he not only admired his talents as an artist, but in all his early practice evidently imitated many of his peculiarities, which he ever after retained. Mr. Northcote further adds, that, 'Sir Joshua told him that, he himself, had seen portraits by Gandy that were similar to, and equal to those of

Rembrandt; one in particular, of an alderman of Exeter which is placed in a public building in that city.'[1] The author of this narrative has seen a much-esteemed picture by Gandy, and is disposed to concur with Mr. Northcote in his opinion that Reynolds might have imbibed, at an early age, a strong impression from studying the works of this artist; and that he carried with him to Italy a recollection of their peculiar, solemn, and forcible effect. Certainly, some of the pictures which Reynolds painted while he was in Devonshire have a depth of tone and colour wholly unlike the flat and insipid pictures of the artists who were then most celebrated in London.

That he made great proficiency under what he considered such disadvantages, was acknowledged by himself at an advanced period of his life, for on seeing some of the portraits he then painted, he lamented, that in so great a length of time, he had made so little progress in his art.

Reynolds remained in Devonshire, thus

1. Portraits by William Gandy survive in the Royal Albert Memorial Museum, Exeter

employed, more than five years, when having made a purse which he deemed equal to the purpose, he prepared to set off for Italy. At this time the Honourable Captain, afterwards Lord, Keppel, being ordered to sail for the Mediterranean as Commodore, he obtained, through the interest of Lord Edgcumbe, a passage for Reynolds in his ship, the *Centurion*, in which he sailed from Plymouth, May 11th, 1749. He was then nearly twenty-six years old. His voyage was made very agreeable to him by the attentions of Captain Keppel, who treated him with the utmost kindness, and gratified his curiosity at every place where the ship touched whenever an opportunity was afforded. The *Centurion* arrived at Lisbon on the 24th of May, where Reynolds saw a bullfight, and many grand religious processions. On the 9th of June the ship arrived at Gibraltar, and after a few weeks proceeded to Algiers, in order to execute the commodore's commission, which was to demand the restitution of money plundered by the corsairs of that state from an English packet boat. On arriving at Algiers, July the 20th, he accompanied Captain Keppel on a visit of state to the Dey, to whom he had the honour of being introduced. On receiving the friendly assurances of that chief, the commodore quitted the African coast, and sailed for

Port Mahon in the island of Minorca. Here, General Blakeney, the governor, would not allow Reynolds to be at any expense while he remained on the island, but took him to his own table. At Port Mahon he was detained nearly two months, owing to an accident: having, when riding, fallen with his horse down a precipice, by which he was so much hurt as to be confined to his room. By that misfortune his upper lip was bruised in such a manner, that the scar was apparent ever after. During his confinement, however, he could not remain idle, but painted many portraits,[1] and made a considerable addition to his travelling fund. His wounds being healed, he proceeded to Leghorn, and from thence to Rome.

In that ancient and venerable city, the metropolis of the arts, Reynolds found everything to excite rapture and astonishment. He wrote to England to exhort some of his professional friends to follow him, telling them, 'that if it were possible to give them an idea of what was to be seen there, the remains of antiquity, the sculpture, paintings, and architecture, &c. they would think it worth while, nay, they would break through all obstacles, and set

(1) None certainly identified

45

off immediately for Rome.' Notwithstanding these expressions of general admiration, the mind of our artist, according to his own declaration, was not then sufficiently cultivated to enable him to appreciate, on a first view, the excellence of the sublime conceptions, and grand execution displayed in the works of Michelangelo, and Raphael, in the Vatican. The probable cause of this insensibility has, perhaps, been already mentioned. The line of art which he had hitherto pursued was of an inferior kind. His mind had been absorbed in the study of real life, of colour, and effect, and consequently his imagination had not been raised above that level. Of the ideal in art he knew little or nothing. Grandeur of composition, dignity of character, abstract refinement of form, had never been the subjects of his contemplation. In the Vatican Reynolds saw the art in majestic simplicity, unadorned by splendour of colour, and unsupported by artificial imposing effects. He had the good sense to be convinced that his disappointment proceeded from his own deficiency, and that he had to commence a new course

Opposite: Mrs. Lloyd, c. 1775. Her pose is taken from a drawing by Raphael, and the composition from a painting by Francesco Imperiali

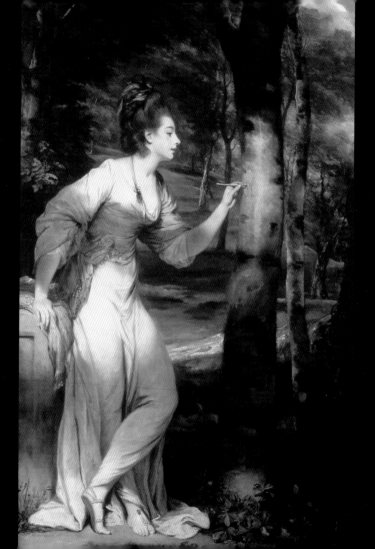

of study to enable him to comprehend the wonders which he saw; and he industriously devoted his whole mind to that object. By judiciously considering these magnificent works, he gradually became sensible of their high quality; and to expand his mind, and acquire a larger practice of the hand, he copied such portions of them as might be afterwards useful to him. He did all that was possible upon the limited foundation he had laid; nor was his labour in vain.

He never was competent to adopt the grand style of art; but by great diligence and attention he enlarged his conceptions, and refined his taste, so as to show in his portraits a new mode of thinking on this branch of the art, perfectly distinct and original. Not any of the great masters who preceded him stood more independently than Sir Joshua Reynolds, and there are peculiar charms and graces in the best of his works, which are seldom, if ever, found in the productions of those eminent artists who had greater general power than he possessed.

The great progress he made in his art, proved the truth of a maxim which he always maintained, 'that all refined knowledge is gradually obtained, and that by study and exertion alone every excellence of

whatever kind might be acquired.' In this principle he was supported by Dr. Johnson, from whom it is not improbable he received it; but in describing his own advance, as given by Mr. Malone, he went too far in saying, 'that all the undigested notions of painting which he brought from England were to be done away and eradicated from his mind.' The truth was, that he had much to learn, but nothing to unlearn. He had little to add to that fine sense of colour which he then possessed, and which, as he long afterwards acknowledged, showed so much promise that all the improvement he could then make upon his limited preparation, was knowledge of composition, taste for form, and general improvement of style: all which he obtained to a certain degree by studying the works of the great masters in Italy.

But if at this period of his life, he was not immediately sensible of the superior excellence of Raphael, he possessed sufficient judgment to pursue a different course from that of many of his contemporaries. On his arrival at Rome, he found Pompeo Batoni, a native of Lucca, possessing the highest reputation. His name was, indeed, known in every part of Europe, and was everywhere spoken of as almost another Raphael; but in that great school of art,

such was the admiration he excited, or rather such was the degradation of taste, that the students in painting had no higher ambition than to be his imitators.

Batoni had some talent, but his works are dry, cold, and insipid. That such performances should have been so extolled in the very seat and centre of the fine arts seems wonderful. But in this manner has public taste been operated upon, and from the period when, art was carried to the highest point of excellence known in modern times, it has thus gradually declined. A succession of artists followed each other, who, being esteemed the most eminent in their own time, were praised extravagantly by an ignorant public, and in the several schools they established, their own productions were the only objects of study.

So widely spread was the fame of Batoni, that, before Reynolds left England, his patron, Lord Edgcumbe, strongly urged the expediency of placing himself under the tuition of so great a man. This recommendation however, on seeing the works of that master, he did not choose to follow: which showed that he was then above the level of those

whose professional views all concentrated in the productions of the popular favourite. Indeed nothing could be more opposite to the spirited execution, the high relish of colour, and powerful effect, which the works of Reynolds at that time possessed, than the tame and inanimate pictures of Pompeo Batoni. Taking a wiser course, therefore, he formed his own plan, and studied chiefly in the Vatican from the works of Michelangelo, Raphael, and Andrea del Sarto, with great diligence; such indeed was his application, that to a severe cold, which he caught in those apartments, he owed the deafness which continued during the remainder of his life.

At Rome Reynolds engaged as a pupil Joseph Marchi, a young Roman about fifteen years of age, who accompanied his master to England; and from him several particulars contained in this narrative were obtained.*

Among other miscellaneous information communicated by Marchi, he mentioned that, during his

* See note p. 225

Overleaf: Parody of the School of Athens, 1751, with caricatures of various English and Irish Grand Tourists. The figure at the extreme right may be a self-portrait

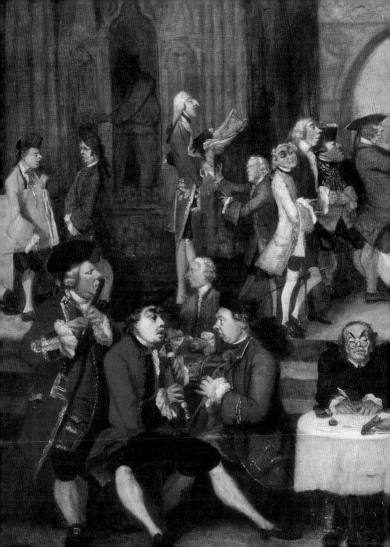

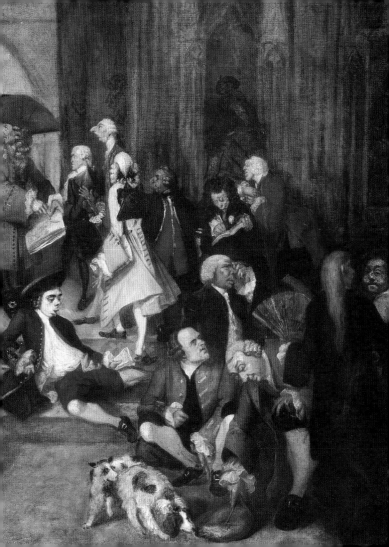

residence in Rome, Reynolds painted several carica-
tures of English gentlemen at their own request, in
which unworthy employment, however, he was not
long occupied, for having made them like, but
ridiculous, they did not relish the degradation, and
therefore suspended their commissions. It is a
remarkable circumstance that such a man could ever
be induced to give up the smallest portion of his
time to a practice so uncongenial with his taste for
refinement, both in and out of his profession.[1]

Excepting in this solitary instance, which has
been noticed by others, much approbation is due to
Reynolds for the good example he showed in his
mode of study while in Italy. He copied but few
whole pictures: considering it, as he afterwards
remarked in one of his discourses, to be 'a delusive
kind of industry, requiring no effort of the mind, or
of those powers of invention and disposition which
ought to be particularly called out and put in action,
which otherwise lie torpid, and lose their energy for
want of exercise.' 'The utter incapacity,' he adds, 'to
produce any thing of their own, of those who had

1 A number of these caricatures survive in the National Gallery of
Ireland, Dublin

spent most of their time in making finished copies, was a common observation with all who were conversant with the art.'

Having completed his course of study, Reynolds left Rome and proceeded to Florence, where he found John Astley, who had been his fellow pupil in the school of Hudson. Astley was then employed in painting portraits, and had the patronage of Sir Horace Mann, the English minister. He had many commissions to copy pictures for English gentlemen, which were chiefly executed by Italian artists.*

While Reynolds remained at Florence, in 1752, he painted a portrait of Joseph Wilton,¹ an English sculptor, which was much admired, as it was a brilliant display of those qualities in which he so eminently excelled; but of the peculiar merits of this picture, he did not then appear to be sufficiently sensible. 'After studying the finest works of the great masters,' he says, a new taste and new perceptions began to dawn upon me, but the notions I had of painting when I left England were not eradicated.' No, nor was it necessary they should be so; his mind

* See note p. 226 1 National Portrait Gallery

had become more enlarged it is true, but the bias of his taste was settled, and the portrait of Mr. Wilton bore much more affinity to his early productions than to anything he had seen in the Vatican.

From Florence he went to Bologna, where he stayed a few days, and from thence proceeded to Parma, Modena, Milan, Padua, and also to Venice, where he remained a month. While in the north of Italy he became, acquainted with Zuccarelli, the eminent landscape painter, in whose house he painted the portrait of a gentleman, in a style which seemed to be new to that artist: for one day when overlooking Reynolds as he proceeded with his work, he turned to Marchi and exclaimed, 'Che spirito ha quest' uomo!' What a spirit this man has!

In this excursion, it appears to have been his custom to procure the usual printed descriptions of each city, on which he made his observations; and having surveyed what each place contained, to such as pleased him best, he repeated his visits, at times most convenient for closer examination. Of many of the works which he saw, he made slight sketches, and accompanied them with notes respecting their peculiar merits, and especially their colouring and effect.

Having completed his tour in Italy, Reynolds proceeded to Turin on his way to England. Between that city and the foot of the Alps, he had the satisfaction to meet on their way to the country he had just quitted, his old master Hudson, accompanied by Roubiliac the sculptor. Hudson, who thought it prudent to perform the customary pilgrimage of artists, was making a hurried visit to the land where art is seen in classical perfection; and the expedition with which he executed his purpose was extraordinary. He was only two days in Rome, and ran from place to place with such speed, that he accomplished his tour in Italy, and returned to Paris before Reynolds had quitted that city, and they came from Calais to Dover in the same packet, so that he could not have been absent from England more than two months.

Reynolds, on his arrival at Lyons, found his finances very low; he had only six louis left, two of which he gave to Marchi with orders to proceed as he could, and reserved four to carry him to Paris, where, in eight days, he was joined by Marchi, who had performed the journey from Lyons on foot. In the French capital our traveller remained a month. Although actively employed in viewing whatever was remarkable in that city, his pencil was not unemployed, as he

there painted the portrait of M. Gotier, which was afterwards engraved.[1]

He arrived in London, October 16, 1752, and proceeded immediately to his native county. There, however, it was not his intention to remain, and, therefore, after a pause of three months he repaired to that city which was destined to be the scene of his future glory. On his return to London he took lodgings in St. Martin's Lane, where Miss Fanny Reynolds, his youngest sister, joined him, in order to take charge of his domestic concerns.

In order to recover his practice, which had been some time suspended, Reynolds commenced his career by painting the portrait of his pupil Marchi, in a Turkish dress.[2] Hudson, and Astley also, who had just returned to England, repeatedly visited him while employed upon this first specimen of his improved art. When it was completed and shown to these gentlemen, Hudson examined it with much attention, and then said, 'Reynolds you do not paint so well now as you did before you went to Italy.'

1 Untraced. There is a copy of the engraving in the British Museum 2 Royal Academy

Opposite: Giuseppe Marchi, 1753

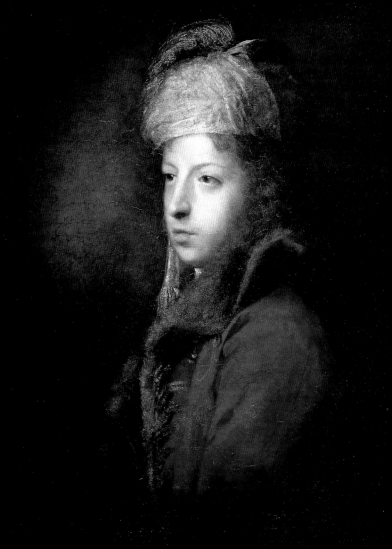

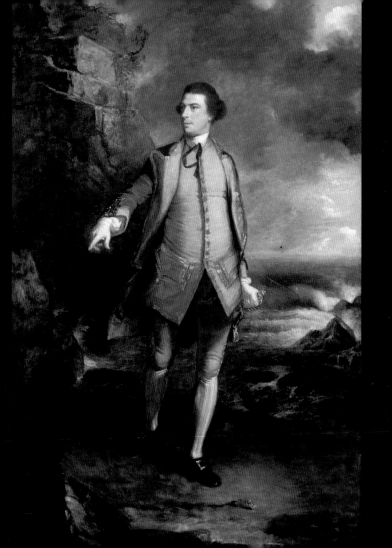

Upon which Marchi noticed a smile on the face of Astley, who doubtless perceived in the remark, the jealousy which still rankled his mind.

The second picture painted by Reynolds was a whole length portrait of his kind friend, now Admiral, and afterwards Lord Keppel.[1] With this picture he took great pains; for it was observed at the time, that, after several sittings, he defaced his work and began it again. But his labour was not lost; that excellent production was so much admired, that it completely established the reputation of the Artist. Its dignity and spirit, its beauty of colour, and fine general effect, occasioned equal surprise and pleasure. The public, hitherto accustomed to see only the formal tame representations which reduced all persons to the same standard of unmeaning insipidity, were captivated with this display of animated character, and the report of its attraction was soon widely circulated.

Immediately after this successful production, he painted several half-length portraits for the

1 National Maritime Museum

Opposite: Augustus, 1st Viscount Keppel, 1752-53

Colebrooke family, viz. Sir James Colebrooke, Sir George Colebrooke, and their Ladies.[2] Lord Godolphin,[2] the Duke of Devonshire,[3] and also many others, sat to him about the same time.

From St. Martin's Lane he removed to a house in Newport Street, where finding his employment rapidly increasing, he was encouraged to raise his prices to a level with those of Hudson.* His application was great; constantly having occasion to receive five, six, or seven persons daily, and some of these frequently at the early hour of six or seven o'clock in the morning: such was his popularity, and the eager desire of numbers to have their apartments graced with productions which possessed the rare quality of uniting the most faithful resemblance to the happiest

1. All private collections, except portrait of Sir James Colebrooke, for which there is no other record. 2. No other record. 3. Chatsworth

* While Reynolds resided in St. Martin's Lane, his prices were for the three usual orders of portraits, namely, a three-quarter, half-length, and whole-length, ten, twenty, and forty guineas. Those of Hudson at the same period were twelve, twenty-four, and forty-eight guineas. Reynolds soon after, however, adopted those of his master, at which they continued four or five years, when they both raised them to fifteen, thirty, and sixty guineas.

traits of expression. The increase of his employment was indeed so great as to oblige him, soon after his removal to Newport Street, to have recourse to an assistant, and for that purpose he engaged Mr. Toms, an artist of much ability, to forward the preparation of his pictures. He also about the same time received Thomas Beach and Hugh Barron as pupils. Yet notwithstanding this extraordinary pressure of commissions, his care and attention never relaxed, and the high reputation he had gained only made him more anxious to increase it. The same unabated desire of improvement occasioned frequent alterations in the progress of his pictures, and it was often long before he could satisfy himself.

It was at this time his acquaintance commenced with Dr. Johnson, who soon became almost a daily visitor at dinner. Miss Reynolds was a great favourite with him, and gratified him by indulging his particular inclinations and habits of life. Reynolds at that time dined at four o'clock, and immediately after dinner, tea was brought in for the Doctor, who, nevertheless, at the usual hour, again took his share of it. After supper, too, he was indulged with his favourite beverage, and he usually protracted his stay till twelve or one o'clock: often very much

deranging, by his immobility, the domestic œcono-
my of the house.

During his residence in Newport Street, Reynolds
painted a portrait of Lord Ligonier on horseback:[1] a
noble performance, which may be classed with any
of his after productions for grandeur of composition
and force of effect. He had not attained his thirty-
sixth year when he executed this fine work, which
showed at once his exquisite taste, and the depth of
his knowledge in those parts of the art to which he
had devoted his incessant attention. Nearly at the
same time he painted a whole-length portrait of the
Duchess of Hamilton,[2] (the beautiful Miss Gunning)
and a smaller picture of her sister, the Countess of
Coventry.[3] He also began a portrait of the Duke of
Marlborough, but the head only was finished,[4] when
the Duke was ordered to join the army in Germany,
whence he never returned.

The variety afforded by the nature of his practice
was happily suited to display the versatility of his
genius. To the Soldier — a character which he

1. Fort Ligonier, Pennsylvania 2. Lady Lever Art Gallery, Port
Sunlight 3. Untraced 4. Wilton House

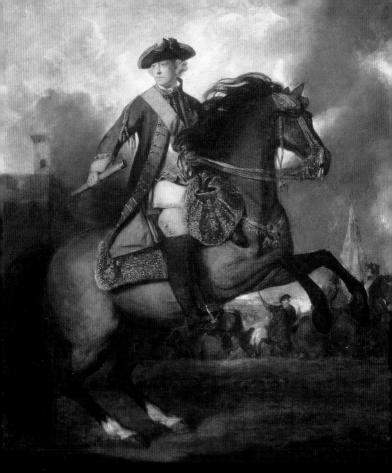

John, 1st Earl Ligonier, 1760

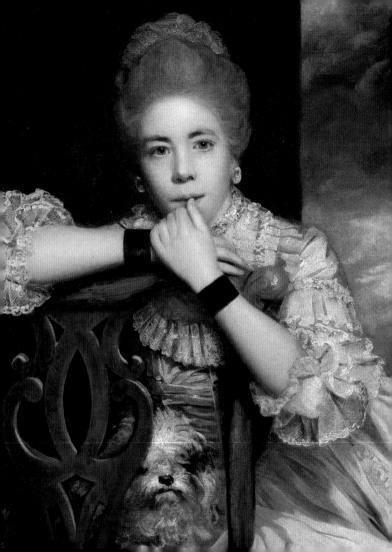

always treated with peculiar energy — he could impart that individuality which distinguishes one man and one hero from another; in female beauty and grace — the delight of his pencil — he evinced the same power of discrimination; therefore, not only the general characters of grave, gay, young and old, but their several species all contributed to supply that variety for which his productions were so remarkable. In fact the capacities of Portrait-painting were never before completely developed.

It might be thought that the talents of Reynolds, to which no degree of ignorance or imbecility in the art could be insensible, added to his extraordinary reputation, would have extinguished every feeling of jealousy or of rivalship in the mind of his master Hudson; but the malady was so deeply seated as to defy the usual remedies applied by time and reflection. Hudson, when at the head of his art, admired and praised by all, had seen a youth rise up and annihilate at once both his income and his fame; and he never could divest his mind of the feelings of mortification caused by the loss he had thus sustained. Hudson occasionally visited his Pupil while

Opposite: Mrs. Abington as 'Miss Prue', 1771

he resided in Newport Street, but neither his excellence nor his prosperity were calculated to produce pleasure; and therefore the intervals of his visits gradually enlarged until they were altogether suspended, which took place twenty years before his death. The latter years of his life Hudson passed at a small villa he had built at Twickenham, where he died, January 26, 1779, seventy-eight years of age.

In the beginning of the year 1760, Reynolds once more changed his residence to a house in Leicester Square, which he inhabited during the remainder of his life.

For the lease of this house, which was for the term of forty-seven years, he paid £1650. But finding it, though large and respectable, still insufficient for his professional purposes, he was obliged to be at the further expense of £1500 for a detached gallery, painting rooms, and such other conveniences as his extensive concerns required; and either to meet these expenses, or to accord with his improved Art and high reputation, he again raised his prices to twenty-five, fifty, and one hundred guineas, for the three orders of Portraits.

At this period, a plan was formed by the artists of the metropolis to draw the attention of their fellow-citizens to their ingenious labours; with a view both to an increase of patronage, and the cultivation of taste. Hitherto works of that kind, produced in the country, were seen only by a few, the people in general knew nothing of what was passing in the arts. Private collections were then inaccessible, and there were no public ones; nor any casual display of the productions of genius, except what the ordinary sales by auction occasionally offered. Nothing, therefore, could exceed the ignorance of a people who were in themselves learned, ingenious, and, highly cultivated, in all things excepting the arts of design.

In consequence of this privation, it was conceived that a *Public Exhibition* of the works of the most eminent Artists could not fail to make a powerful impression, and, if occasionally repeated, might ultimately produce the most satisfactory effects.

The scheme was no sooner proposed than adopted, and being carried into immediate execution, the result exceeded the most sanguine expectations of the projectors. All ranks of people crowded to see

the delightful novelty; it was the universal topic of conversation; and a passion for the arts was excited by that first manifestation of native talent, which, cherished by the continued operation of the same cause, has ever since been increasing in strength, and extending its effects through every part of the Empire.

The history of our exhibitions affords itself the strongest evidence of their impressive effect upon public taste. At their commencement, though men of enlightened minds, could distinguish and appreciate what was excellent, the admiration of the many was confined to subjects either gross or puerile, and commonly to the meanest efforts of intellect; whereas at this time the whole train of subjects most popular in the earlier exhibitions have disappeared. The loaf and cheese, that could provoke hunger, the cat and canary-bird, and the dead mackerel on a deal board, have long ceased to produce astonishment and delight; while truth of imitation now finds innumerable admirers, though combined with the high qualities of beauty, grandeur, and taste.

To our Public Exhibitions, and to arrangements

that followed in consequence of their introduction, this change must be chiefly attributed. The present generation appears to be composed of a new, and, at least with respect to the arts, a superior order of beings. Generally speaking, their thoughts, their feelings, and language on these subjects, differ entirely from what they were sixty years ago. No just opinions were at that time entertained on the merits of ingenious productions of this kind. The state of the public mind incapable of discriminating excellence from inferiority, proved incontrovertibly, that a right sense of art in the spectator, can only be acquired by long and frequent observation, and that without proper opportunities to improve the mind and the eye, a nation would continue insensible of the true value of the fine arts.

The first or probationary Exhibition, which opened April 21st, 1760, was at a large room in the Strand belonging to the Society formed for the Encouragement of Arts, Manufactures, and Commerce, which had then been instituted five or six years. It is natural to conclude, that the first artist of the country, was not indifferent to the success of a plan which promised to be so extensively useful. Accordingly four of his pictures were, for the first

time, here placed before the public, with whom, by the channel now opened, he continued in constant intercourse as long as he lived.

Encouraged by the successful issue of the first experiment, the artistical body determined that it should be repeated the following year. Owing, however, to some inconveniences experienced at their former place of exhibition, and likewise to a desire to be perfectly independent in their proceedings, they engaged for their next public display, a spacious room near the Spring Gardens entrance into the Park; at which place the second exhibition opened May 9th, 1761. Here Reynolds sent his fine picture of Lord Ligonier on horseback, a portrait of the Rev. Lawrence Sterne,[1] and three others.

It is possible, that the immediate pecuniary profits arising from this Exhibition might not have entered into the views of the first projectors; but when it is remembered what important uses these were afterwards applied to, and reflecting on the still greater consequences hereafter to be expected from the same source of income, it may not be improper

1. National Portrait Gallery *Opposite: Revd. Laurence Sterne, 1760*

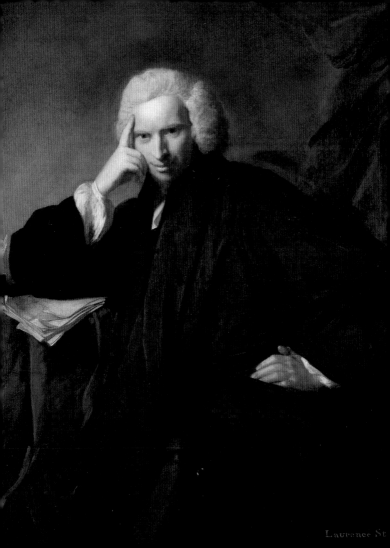

to mention the commencement of this fund.

On their first appeal to the public, the Artists required no admission-money, but sixpence was charged for the catalogue of the works exhibited. The year following, the price for catalogues was doubled; and on the third year, encouraged by their extraordinary success, one shilling was demanded for admission, and sixpence for the catalogue; placing on the front of it an advertisement written by Dr. Johnson, to reconcile the public to the charge which had been made for admission.

To this Exhibition, Reynolds sent his picture of *Garrick between the two Muses of Tragedy and Comedy*,[1] and two other portraits. The following year he contributed four pictures to the public show, and in 1764, two portraits. In 1765 he sent his beautiful picture, called *A Lady sacrificing to the Graces*,[2] which was the portrait of Lady Sarah Bunbury. This, like many other of his pictures, was a novelty in the art, showing individual likeness, combined with an assumed character.

1. Rothschild Collection, Waddesdon Manor
2. Art Institute of Chicago

The artists had now fully proved the efficacy of their plan; and their income exceeding their expenditure, affording a reasonable hope of a permanent establishment, they thought they might solicit a Royal Charter of Incorporation; and having applied to His Majesty for that purpose, he was pleased to accede to their request. This measure, however, which was intended to consolidate the body of artists, was of no avail; on the contrary, it was probably the cause of its dissolution; for in less than four years a separation took place, which led to the establishment of the Royal Academy, and finally to the extinction of the incorporated society. The charter was dated January 26th, 1765; the secession took place in October, 1768; and the Royal Academy was instituted December 10th in the same year.

In 1766, Reynolds exhibited four pictures; the next year he remitted, and in the spring of 1768, he sent four. This year an exhibition was formed for the gratification of the King of Denmark, at that time in England. It opened on the 13th of September, and contained four pictures by Reynolds, and these were the last he exhibited with the incorporated society.

Overleaf: Garrick between the Muses of Tragedy and Comedy, 1760-61

The dissolution of the incorporated body of artists was owing to the indiscriminate admission of members. At the period of the separation, the number amounted to one hundred and forty-one, of whom a large proportion were of a very inferior order. When the Society was first instituted, due respect was shown to the eminent artists who by the propriety of their conduct, and the esteem in which they were held, gave dignity to it, and by their excellent performances contributed most to the popularity of the Exhibitions. They were, therefore, for a while, considered to be the persons most proper to have a large share in the government of the Society. While that sentiment prevailed it proceeded with success. But it was not long before ambitious desires began to operate; and the votes at elections being equal, many of the members, who had little title to confidence and distinction, aspired to the direction of the Institution, and by combining together they were, by their numbers, enabled to effect their purpose. They ejected two-thirds of the respectable members who filled the offices of trust, and placed themselves in their room; and forming a majority, outvoted those whom they had permitted to remain. The principal artists seeing the impossibility of restoring order and proper subordination, after

some vain attempts, soon withdrew from this Society; and without delay formed another plan in which they avoided the errors which caused the destruction of the incorporated body they had quitted. It was now seen that no Society of this kind could be lasting unless it were more limited in its number, and select in the choice of its members; and that it could have no national dignity without the avowed and immediate patronage of the Sovereign. Happily there were artists among the seceding members who, in the situations in which they were placed, had opportunity to state these sentiments to His Majesty, who graciously approved the proposal submitted to him, and directed that the plan should be carried into execution; and thus in a short time the Royal Academy was established.

During the dissensions in the Incorporated Society, Mr. Reynolds took no active part; and his apparent neutrality caused it to be believed by many of its members that he did not approve of the proceedings of those who had retired from it. On the subject of the disunion Mr. Strange, the eminent engraver, published a book in which he bitterly arraigned the conduct of those who had seceded. And in his account of the cause and effect of the

separation, he states that Mr. Reynolds said 'he would not exhibit with either Society,' and he proceeded to reproach him with having given up this resolution when tempted with the offer of the Presidency of the Royal Academy then forming, and an assurance that he would be honoured with knighthood. This accusation of inconsistency, when moved by ambition, Mr. Strange remarks upon in a manner calculated to depreciate the character of Mr. Reynolds, and will be best opposed by what the latter declared publicly, while all the circumstances of the separation were fresh in the recollection of those whom he addressed.

The Royal Academy was opened on the 2nd of January, 1769, when the President, Mr. Reynolds, read his first discourse, which commenced as follows:

GENTLEMEN,

An Academy, in which the polite arts may be regularly cultivated, is at last opened among us by royal munificence. This must appear an event in the highest degree interesting, not only to the Artists, but to the whole nation.

It is, indeed, difficult to give any other reason, why an Empire like that of Britain should so long

have wanted an ornament so suitable to its great-
ness, than that slow progression of things, which
naturally makes elegance and refinement the last
effect of opulence and power.

An Institution like this has been often recom-
mended upon considerations merely mercantile;
but an Academy, founded upon such principles,
can never effect even its own narrow purposes. If
it has an origin no higher, no taste can ever be
formed in manufactures; but if the higher arts of
design flourish, these inferior ends, will be
answered of course.

We are happy in having a Prince, who has
conceived the design of such an Institution,
according to its true dignity; and who promotes
the Arts, as the head of a great, a learned, a
polite, and a commercial nation; and I can now
congratulate you, Gentlemen, on the accomplish-
ment of your long and ardent wishes.

*The numberless and ineffectual consultations which I
have had with many in this assembly, to form plans, and
concert schemes for an Academy, afford sufficient proof of
the impossibility of succeeding* without the influence
of *Majesty* &c. &c.

Such being the avowed sentiments of Mr.
Reynolds it will naturally be believed, that, though

he left to others who were better situated the more active part of planning and of proposing to His Majesty the establishment of a *Royal Academy*, he still highly approved the measure.

Mr. Strange also condemned the conduct of Mr. Reynolds, because it appeared he consented to the exclusion of engravers from the rank of academicians; and also because he had been informed that the President had affirmed that 'Engravers were men of no genius, servile copiers, and consequently not fit to instruct in a Royal Academy.' Mr. Strange considered this attack upon the art of engraving as directed particularly against himself, and that 'the total exclusion of engravers, was to prevent any chance he might have of partaking the honours the academicians were sharing.'

Mr. Strange was so far disposed to acquit Mr. Reynolds, as not 'to charge him with being the proposer of the exclusion, he having only given his assent to what was urged by others. But this was a great deal too much if his heart condemned him.' Mr. Strange proceeds to say, that 'no man could have wished for a fairer opportunity of doing

Opposite: the engraver James McArdell, c. 1756

himself credit, by serving the arts essentially, than Mr. Reynolds had, when he was made President of the Royal Academy. He could 'easily have obliterated the unhappy divisions, which a few designing men had raised up. He could have united the arts, and have protected them in all their branches. But it was to be lamented, that he adopted measures not his own, and supported a plan that was dictated by selfishness, ambition, and resentment.'

Such was the report published by Mr. Strange, a very able professor of his art, and a respectable man*; but in this instance misled by unjust suspicion and jealousy. The fact was, that Sir Joshua Reynolds held the ingenuity of able engravers in high consideration; but he would not admit that works purely imitative should be classed with original productions, or that the professors of the former were entitled to the distinction granted to the latter, which requires more profound study and greater powers of mind. Mr. Strange, in his publication, endeavoured to make it appear, that the profession to which he belonged was sacrificed to gratify malignant feelings towards himself; but it was afterwards shown that

* See note p. 228

this apprehension was unfounded. At a subsequent period Sir Joshua Reynolds, in reply to the remonstrance of another engraver who asserted the claim of those of his profession to be admitted academicians, returned an answer decisive against it, which prevented his having any further application made to him on the subject.

January 2nd, 1769, the thanks of the General Assembly of Academicians were given to Mr. Reynolds for the excellent discourse which he delivered on the opening of the Royal Academy; and shortly after he had the honour of knighthood conferred upon him by His Majesty.

Sir Joshua Reynolds was now in the forty-sixth year of his age; his superior eminence in the art was acknowledged by the unanimous votes which placed him in the chair of the Royal Academy, a situation in which he was enabled to display, in his admirable discourses, the extent of his knowledge of the principles of an art which he so highly adorned by his practice; and to inculcate, by precepts founded upon long observation and matured experience, lessons of wise instruction for the student, and calculated to excite in the public mind respect for an art in which

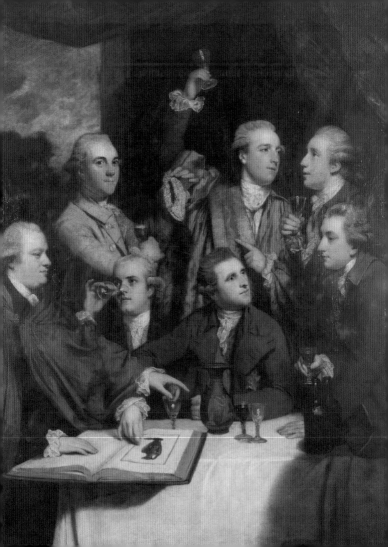

he showed, that, (with the most favourable talents) excellence could not be attained without great mental and bodily application.

But it was not by the productions of his professional skill, and cultivated taste only, that Sir Joshua Reynolds attracted admiration; his exemplary moral conduct, his amiable and well-regulated temper, the polished suavity of his manners, a deportment always easy and unaffected, made his society agreeable to everyone. At the period at which the narrative is arrived, his house in Leicester Fields was resorted to by the most distinguished characters in the country: — men eminent for their genius, learning, and knowledge. He kept what might be almost called an open table, at which were daily seen in larger or smaller numbers, poets, historians, divines, men celebrated for their scientific knowledge, philosophers, lovers of the Arts, and others. Dr. Johnson and Dr. Goldsmith were of those who most frequently were of this assembly of rare persons. It was in such company that

Opposite: The Society of Dilettanti, 1777-79. First painting: Left to right: Sir Watkin Williams Wynn, in the robe of the President of the Society; (Sir) John Taylor FRS; Stephen Payne-Gallwey; Sir William Hamilton; Richard Thompson; Walter Spencer-Stanhope; John Lewin Smyth (added later)

he gradually improved his mind, and formed his taste for literary composition and grace of expression. Two thousand pounds per annum, it is said, was the expense of his establishment: — a considerable sum according to the value of money at that time; but he wisely judged that to be a prudent expenditure which procured him such advantages. His professional income was said by himself to be six or seven thousand pounds per annum. He had then six pupils and two other assistants, who were occupied upon the preparation and subordinate parts of his pictures: all of whom were fully employed.

Such an example at the head of the arts had the happiest effect upon the members of the profession. At this time, a change in the manners and habits of the people of this country was beginning to take place. Public taste was improving. The coarse familiarity so common in personal intercourse was laid aside; and respectful attentions and civility in address, gradually gave a new and better aspect to society. The profane habit of using oaths in conversation no

Opposite: The Society of Dilettanti, 1777-79 Second painting: Constantine John Phipps, 2nd Lord Mulgrave; Thomas (later Lord) Dundas; Kenneth Mackenzie, 1st Earl of Seaforth, FRS, FSA; Charles Greville; John Charles Crowle; Lord Carmarthen; (Sir) Joseph Banks

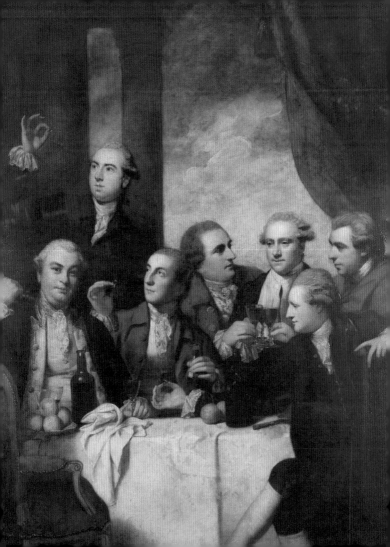

longer offended the ear, and bacchanalian intemperance at the dinner-table was succeeded by rational cheerfulness and sober forbearance.

No class of society manifested more speedy improvement than the body of Artists. In the example set by Sir Joshua Reynolds, he was supported by some of his contemporaries who were highly respected for the propriety of their conduct and gentlemanly deportment. So striking was the change, that a much-esteemed Artist, far advanced in life, being a few years since at a dinner-table surrounded by men of his own profession, recollecting those of former times, remarked the great difference in their manners, adding, 'I now see only gentlemen before me.' Such is the influence of good example.*

It has often been remarked, that Sir Joshua Reynolds had many pupils, but that he produced few whose works entitled them to much notice. To those who have slightly considered the subject of education, and especially in art, this circumstance must appear extremely paradoxical, although, in fact, it is precisely what might be expected.

* See note p. 230

The school of Sir Joshua resembled a manufactory, in which the young men who were sent to him for tuition were chiefly occupied in copying portraits, or assisting in draperies and preparing backgrounds. The great pressure of his business required not only his own unceasing diligence, but that every hand he could command should be employed, to enable him to execute the numberless commissions that poured in upon him. The consequence was, that his pupils had very little time for deliberate study; and that which was left them after the application they had given in the day was usually spent in relaxation after labour.

In this manner years passed away, and produced no solid improvement. While his pupils remained under the eye of their master, by constantly working upon, or copying his pictures, they seemed to be doing much; but on their leaving him, they soon discovered their mistake in the total absence of all independent ability. Not having been sufficiently accustomed to think for themselves, they looked to his pictures for everything, and submitting their minds to excellence so captivating, their thoughts extended no farther. Nature was seen by them only through his medium, and when deprived of that aid they gradually exposed their imbecility.

It seems remarkable, that of eight or nine pupils, many of whom at their commencement indicated considerable talent, Mr. Northcote should be the only one who has attained distinction. Possibly, this fortunate exception was owing to his having sought that distinguished tuition at a later period of his life than is usual; and at a time too when his instructor was less occupied with commissions, and himself with a mind more disposed to reflection than might be reasonably expected at an earlier age.

It was observed that those Artists who were not connected with Sir Joshua by any engagement, but, while proceeding in their studies, occasionally requested him to inspect their pictures, and afford them his advice, profited much more by his instruction than those who had daily intercourse with him. Here the student united the advantages of independent practice with that of judicious advice in cases where it was urgently required.

Thus in the example of his own pupils, the unquestionable truth of the observations quoted from his discourses in the early part of this memoir, was fully confirmed. While in Italy, it is there stated that he copied but few pictures, from a conviction, as

he said, that 'it was a delusive industry, requiring no effort of mind, no powers of invention or composition, — which ought to be called into vigorous action: otherwise they become torpid, and lose their energy from the want of exertion.'

His attention to the annual Exhibitions was unremitting, and his example admirable. His situation of President, and his high claim, from the superlative excellence of his pictures, never caused him, to avail himself of those circumstances, to obtain any particular regard to his own works. He was only anxious that the display should be advantageous, and that the exhibitors should be satisfied with the attention shown to their productions. His gallery was open, from whence pictures might be taken in such number as might be required; and if he expressed any wish concerning them, it was that a portion at least should be placed in situations accounted least favourable for viewing them: thereby to reconcile others to their necessary lot.

Overleaf: The Exhibition at the Royal Academy in 1787 (Pietro Antonio Martini after Johann Heinrich Ramberg). The room is now part of the Courtauld Institute of Art in Somerset House. Reynolds is seen in the centre, ear-trumpet in hand, with the Prince of Wales. His portrait of the Prince is seen at the centre of the wall behind them (see p. 98) . The portrait of Boswell (see p. 107) is in the bottom row at the right

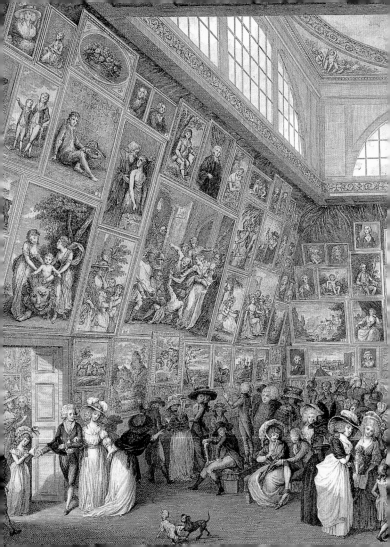

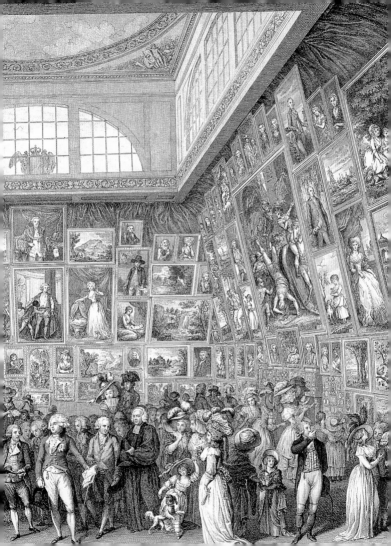

He had great pleasure in viewing the exhibition of each year, and in his observations he was gentle and encouraging: for no man could be more free from jealousy. He always appeared to take great delight in remarking the extraordinary variety shown in the practice of British Artists, which, he said, was not to be seen in any other country. The independence of the national character, he thought, was apparent even in our works of art, which, through all their gradations of merit, showed that they were the productions of men who thought for themselves; and who, regardless of the paths beaten by others, followed the bent of their own inclinations. The variety thus afforded made the English Exhibition infinitely amusing.

From the time of his being made President of the Royal Academy, Sir Joshua undoubtedly did all in his power to realize the earnest desire of His Majesty, that his Institution should be no less respectable as a national establishment, than useful in its purposes. It was with a view to improve the liberal character of the Society, that he suggested the idea of admitting in its body certain honorary members, eminent for their learning; who, while they added grace to the Institution, received from it an

honour worthy of their distinguished talents.

Accordingly soon after the Royal Academy was established, His Majesty was graciously pleased to nominate Dr. Johnson professor of ancient literature; Dr. Goldsmith professor of ancient history, and Richard Dalton, Esq., His Majesty's librarian, antiquary to the Society. Dr. Franklin, the Greek professor at Cambridge, was also appointed chaplain to the Academy. To these, who were the first honorary members of the Institution, many names of great celebrity have succeeded.

Another measure, which originated in the same source, should here be mentioned. From the first establishment of the Royal Academy, it has been annually the custom of the members to dine together in the Exhibition Room, after the pictures had been arranged. This meeting was for several years held on St. George's day, and the day following the Exhibition commenced. On these occasions, it was usual to invite several persons distinguished for rank or talent; and as festive entertainments given under circumstances so novel could not fail to be spoken of with interest and satisfaction by the invited guests, a pressure of applications to this annual treat has been

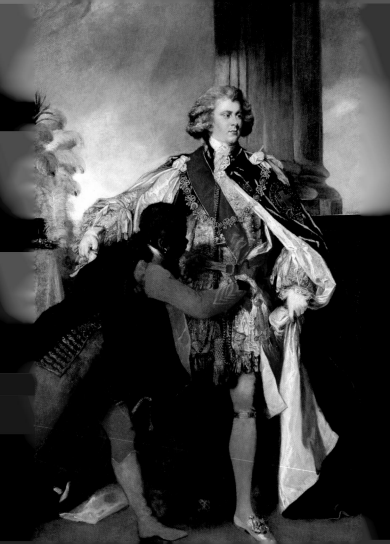

the consequence, which, to the present moment, has never relaxed.

To Sir Joshua Reynolds, these entertainments were highly agreeable; and anxious that the company assembled at such times should be as select as possible, he earnestly recommended that the Council should give up all private wishes in their invitation. To secure a permanent effect, therefore, to the President's advice, a law was made to limit their invitations to persons high in rank or official situation; to those distinguished for superior talent; and to patrons of the art. By attending to this rule, the opening dinners of the Exhibition of the Royal Academy became celebrated. The Prince of Wales has repeatedly honoured them with his presence, and generally some of the Princes of the Royal Family appear at them. The ministers of state, and other high political characters attend, and many of the heads of the Church always form part of the company. At the dinner given in 1784, Dr. Johnson left his seat by desire of the Prince of Wales, and went to the head of the table to have the honour of being introduced to his Royal Highness. This was his

Opposite: The Prince of Wales with a black servant, c. 1786-87

last visit to the Academy. He died on the 13th of December in that year.

These dinners at the Royal Academy have been sometimes peculiarly interesting. In 1786 the Prince of Wales had on his right hand the Duke of Orléans, accompanied by the Dukes de Lauzeen and Fitzjames, and the Count de Grammont. The Duke of Orleans sat under the fine whole-length portrait of his Royal Highness, painted by Sir Joshua Reynolds,[1] and afforded the company present an opportunity to compare the admirable representation with the original. This ill-fated Prince had much personal dignity. Sir Joshua, remarking how few persons appear with grace and ease when the arms are wholly unemployed, said, he never saw any man stand in such a position so well as the Duke of Orleans. He had then not long to remain in this world. Influenced by his passions, his political career ended in his destruction.

In mentioning these entertainments, it is gratifying to record a tribute of respect paid to a most

1. Royal Collection

Opposite: The Duke of Orléans, 1786, mezzotint by John Raphael Smith after Reynolds; the original was damaged by fire at Carlton House

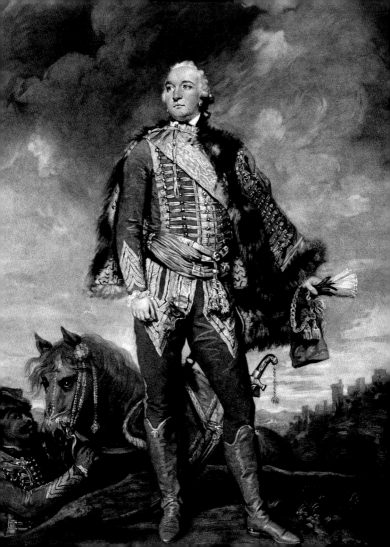

worthy man, who passed a long life endeavouring to benefit his country: — the late Alderman Boydell.

At an Exhibition dinner at the Royal Academy in 1789, which the Prince of Wales honoured with his presence, Mr. Burke seeing Alderman Boydell at one of the tables while toasts were circulating, wrote the following note to Sir Joshua Reynolds, who sat as President. 'This end of the table, in which, as there are many admirers of the art, there are many friends of yours, wish to drink an English Tradesman, who patronizes the art better than the Grand Monarque of France:

Alderman Boydell, the Commercial Mæcenas.'

This note was shewn to the Prince of Wales by Sir Joshua Reynolds, and highly approved by his Royal Highness, and the toast was drank with unanimous approbation. The alderman was then in the sixty-sixth year of his age.

This excellent citizen, by prudent conduct and unceasing application, accumulated property which enabled him to form and to execute plans for the advancement of art, and the encouragement of Artists, before unknown in this and scarcely in any

other country. At the time he commenced publishing prints, the art of engraving was in a very low state in England. Little was sought for but French prints, and large remittances went annually to purchase them. Mr. Boydell, moved less by hope of gain than by patriotic feelings, resolved, if possible, to turn the tide in favour of his native country. He knew this could only be done by improving the practice of our professors in that department.

For this purpose he used all the money he acquired, in employing our most ingenious engravers to execute prints from pictures painted by eminent masters, by which means he called forth all their powers, and in a few years Mr. Boydell's success was complete. English prints became popular, not only in England, but throughout the Continent. The balance of trade in this article turned in our favour, and while the works of Woollett, Sharp, and others, were seen as the favourite ornaments of houses in Britain, they were sought for in France with almost equal avidity. Encouraged by his success, Mr. Boydell undertook to have engravings made from the whole of the celebrated collection of pictures at Houghton Hall in Norfolk, which was formed by Sir Robert Walpole, Earl of Orford, while

he was prime minister. When this was completed, he proposed to the public his grand plan to form a gallery of pictures, to be painted by British Artists from subjects taken from the plays of Shakespeare; an undertaking which afforded great employment for painters, who thus had an opportunity to show their powers in the higher department of the art; and full occupation for every ingenious engraver.

It was while this great work was carrying on, that Mr. Burke, a man reverenced by his country, availed himself of the opportunity which has been described to express his opinion of the merits of our worthy citizen.*

For Boydell's gallery of Shakespeare, Sir Joshua Reynolds painted two pictures, *The Death of Cardinal Beaufort*,[1] for the play of Henry VI and the scene of *Macbeth with the Witches*,[2] for which picture he was paid one thousand guineas; a third, the picture of *Puck*,[3] though not painted expressly for the gallery, was purchased by the Alderman and applied to that work.

* See note p. 232 1. & 2. Petworth House 3. Private Collection
Opposite: Dr. Johnson, c. 1772-78; painted for Henry Thrale's library

Having thus introduced the name of Mr. Burke, it may here be said, that of all the distinguished men with whom Sir Joshua was acquainted, that great man stood highest in his estimation of their mental powers. He thought Dr. Johnson possessed a wonderful strength of mind, but that Mr. Burke had a more comprehensive capacity, a more exact judgment, and also that his knowledge was more extensive; with the most profound respect for the talents of both, he therefore decided that Mr. Burke was the superior character. Sir Joshua and Mr. Burke were for a great length of time warmly attached to each other. The death of the former preceded that of the latter only a few years, and the sorrow expressed by the survivor on that occasion showed the heartfelt affection he had for his departed friend.

Sir Joshua Reynolds had great pleasure in Society, and enjoyed cheerful intercourse when regulated by delicacy and good manners. Of those who were frequently of his parties, Mr. Boswell, the author of the admirable *Life of Dr. Johnson*, was very acceptable to him. He was a man of excellent temper, and with much gaiety of manner, possessed a shrewd under-

Opposite: James Boswell, 1785

standing and close observation of character. He had a happy faculty of dissipating that reserve which too often damps the pleasure of English society. His good nature and social feeling always inclined him to endeavour to produce that effect, which was so well known, that when he appeared, he was hailed as the harbinger of festivity. Sir Joshua Reynolds was never more happy than when, on such occasions, Mr. Boswell was seated within his hearing. The Royal Academy gratified Sir Joshua by electing Mr. Boswell their secretary for foreign correspondence, which made him an honorary member of their Body.

In his capacity of President, Sir Joshua, as before stated, read the first of his admirable discourses on the Fine Arts on the opening of the Royal Academy, January 2nd, 1769, and every second year, from that time, when the premiums of gold medals were given to the students of the Academy, he delivered a similar address; the last, which was the fifteenth, he read on the 10th of December, 1790, to a crowded assembly, in which many distinguished characters appeared among his auditors.

Opposite: the Scottish philosopher Adam Ferguson, the 'father of sociology', 1781-82 – a painting that looks forward to the work of Sir Thomas Lawrence, a later President of the Royal Academy

Thus did this great artist pursue his course, without relaxation or intermission, in the study or practice of his art, still, nevertheless, making his application consistent with an extended intercourse with society.

So attached was Sir Joshua to his painting-room, that he very seldom could be induced to leave London.* He said, that if he made a visit for three days, his thoughts became unsettled; and on his return home, it required three days more before he could recover his train of thinking. It might be a question whether his mode of life was not unfavourable for its prolongation. He had excellent

* In the summer of 1781, he made the tour of Holland and Flanders; and in 1783, in consequence of the Emperor's suppression of some of the religious houses, he again visited Flanders. These excursions were made with a view to his improvement in his art, and the fruits of his valuable observations are given to the public. From his arrival in England from Italy in 1753, till his death in 1792, a period of thirty-nine years, excepting on the above occasions, and twice visiting his native county, he never was absent from his painting-room for more than a few days at a time; but he occasionally, though seldom, made short visits to his friends, who resided within a moderate distance of the metropolis.

Sir Joshua Reynolds built a house for himself on Richmond Hill; and it is remarkable, that though he frequently visited it, he never, it is said, passed a night there.

health, and when sixty-six years old, on being congratulated upon his healthy and youthful appearance, he said he felt as he looked, having no complaint; but the disorder which caused his death might have been long gradually, though insensibly, forming. Though becomingly temperate in his diet, he did not live abstemiously, and had no other exercise but that which, with his palette in his hand, he took while painting, which he did standing, to see the effect of his picture by receding from it.

The result of this unceasing application was, that the number of pictures he produced was very great. Including the whole sent by him to public exhibitions was 252, viz. to the Society's room in the Strand 4, to the Incorporated Society 20, and to the Royal Academy 228. This was only a select portion of the pictures he executed; his industry was perhaps unexampled.

In 1788, Sir Joshua Reynolds exhibited at the Royal Academy his picture of *Hercules strangling the Serpents*.[1]

The subject of this grand picture is allegorical, alluding to the improvement which has taken place

in the Russian empire within the last century. It was painted by order of the Empress Catharine, whose commission was unlimited both in subject and in price.

Soon after the picture arrived at St. Petersburgh, Count Woronzow, the Russian ambassador, waited on Sir Joshua Reynolds, to inform him, that the picture he painted for the Empress of Russia had been received at St. Petersburgh, with the two sets of his *Discourses*, one in English and the other in French, which, at the desire of Her Imperial Majesty, had been sent with the picture.

At the same time, Count Woronzow delivered to Sir Joshua a gold box, with the Empress's portrait upon it, encircled with very large diamonds, &c. containing a most gracious expression of her approbation written by her Imperial Majesty's own hand. The ambassador left also with Sir Joshua a copy of the following letter, which he had received from the Empress with the said valuable present.

Monsieur le Compte Woronzow,
I have read, and, I may say, with the greatest avidity, those discourses pronounced at the Royal

Academy of London, by Sir Joshua Reynolds, which that illustrious artist sent me with his large picture; in both productions one may easily trace a most elevated genius.

I recommend to you to give my thanks to Sir Joshua, and to remit to him the box I send, as a testimony of the great satisfaction the perusal of his *Discourses* has given me, and which I look upon as, perhaps, the best work that ever was wrote on the subject.

My portrait, which is on the cover of the box, is of a composition made at my hermitage, where they are now at work about impressions on the stones found there.

I expect you will inform me of the price of the large picture, of the subject of which I have already spoke to you in another letter.

Adieu — I wish you well.

(Signed) CATHARINE.

St. Petersburgh, March 5, 1790.

Happy as was the general progress of Sir Joshua Reynolds throughout life, his course was not wholly untroubled. Solicitude to obtain further knowledge of his art, was always the prevailing feeling in his mind. This caused him to make experiments in using his colours, although he had not acquired, in

the earlier part of his life, sufficient chemical knowledge to enable him to judge of the result; and he was so much occupied upon urgent commissions, that he had no time for this purpose. Being so circumstanced, he made his experiments upon the portraits he was painting, and many of them failed. The fact was, that, for some time, he worked upon a principle of commencing his pictures with cold colours, and finishing them by what painters call glazing, viz, thin colours passed over a nearly finished preparation. Some of the thin colours he employed were of a fugitive nature, and in a little time lost their brilliancy. This caused much complaint, which, in truth, was too well founded, for many of his pictures were reduced almost to the state of painting in chiarooscuro; but having seen his error, he became more careful; and fortunately his best works have proved to be those in which the colouring is permanent.

Eminent above all rivalship, as our great artist was, he experienced the uncertainty of popular favour. At two or three periods, public (not professional) opinion

Opposite: The Marquess of Rockingham and Edmund Burke, begun 1766. Based on a Van Dyck belonging to Rockingham, this unfinished work shows Reynolds' technique of laying in cold colours prior to painting in glazes. The accesssories were painted by an assistant

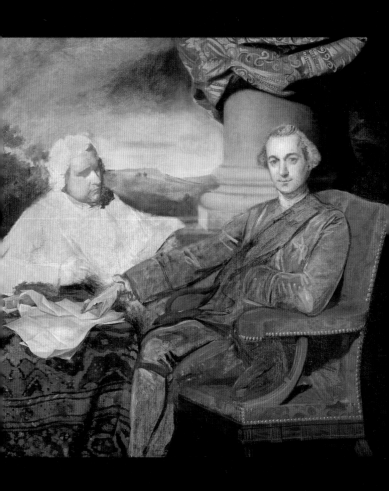

fluctuated between Sir Joshua, and some artists whose works engaged much attention. At one time his employment slackened in consequence of Mr. Gainsborough's rising popularity; and Mr. Romney's portraits were so much admired, that he was held up as a formidable rival. The late Lord Chancellor Thurlow, when at an advanced age, sat to Mr. Hoppner for his portrait, and in the course of conversation sometimes questioned him respecting the state of the art. 'At one time,' said his Lordship, 'there were two factions contending for superiority; the Reynolds faction, and the Romney faction: I was of the Romney faction.' This point has been long settled; however respectable the pictures painted by Romney are, no one will now mention them in competition with those of Reynolds. It is remarkable, that Lord Thurlow could hold the opinion he did, as the portrait of his Lordship, painted by Sir Joshua Reynolds,[1] is one of his finest productions: but the powers of Lord Thurlow appear to have been confined to his own profession, and did not extend to matters of taste. His judgment respecting poetry is said to have been no less deficient, than it was on the subject of painting.

1. Longleat House

If it be asked how Sir Joshua Reynolds bore himself under these fluctuations which his reputation experienced, it may be truly answered, that his conduct was consistent with the description given of his character. He proceeded calmly and unruffled to correct the errors of his professional practice, still endeavouring to attain higher excellence; and he left to others to debate upon his merits and his deficiences, and never appeared to be affected by contending opinions. Whether his popularity was greater or less, whether his pictures were more or less in request, it seemed to be unnoticed by him; one by one, his rivals dropped off into their true situation, and before the conclusion of his life, it was universally acknowledged that he had no equal in the art.

Among other attacks which he sustained, was a formal effort made to shew, that he had no power of invention; that he was a decided plagiarist; and that his designs for groups of figures, and of attitudes for his portraits, were stolen, as it was termed, from prints engraved from the works of various masters; and in the hope of lowering the high reputation of this great man, an artist was so illiberal as to undertake to prove this charge to the public. For this purpose Mr. Hone, one of the academicians, who paint-

ed portraits in oil, miniature, and crayons, painted a large picture, in which he introduced a grave personage surrounded by various works of art, and holding a wand, with which he pointed to a number of scattered prints, and under them, slight indications of such of Sir Joshua's pictures as, in design, most resembled them. The title he gave to this picture was, *The Conjuror*. The principal figure in the composition was supposed to be a wizard, who had discovered by his skill in the black art these proofs of Sir Joshua's plagiarism. Desirous that his satire should have its full effect, the painter sent it to the Royal Academy for exhibition in 1775; but the Council, perceiving his illiberal intention, of course rejected it. Disappointed here, he made an exhibition of his own works only, in which *The Conjuror* occupied a principal point; but this impotent attempt to lower Sir Joshua in the public estimation produced little or no effect The public in general, equally ignorant of the merits of originality, and the crime of plagiarism, had no opinion on the subject; Artists detested the malignity of the intention, and the great object of the satire was a man not to be moved by such calumnies.

1. National Gallery of Ireland

Circumstances like these, occurring to such an artist and such a man, must shew the inexperienced that no reputation will be uninterruptedly permanent, but that, on the contrary, those who have the most just claim to lasting admiration, will occasionally find that public opinion, caught by ignorant report, turns from its proper object, and, as if satiated with higher excellence, becomes clamorous in favour of novelty. The conduct of Sir Joshua Reynolds, affords an admirable example to those who may be liable to the same vicissitudes.

Thus he continued his even course in the practice of his profession, until the summer of 1789, when in the month of July, while he was employed in finishing a portrait of Lady Beauchamp (now Marchioness of Hertford)[1] the last female portrait he ever painted, he suddenly perceived a dimness in his left eye, which he described as something like the falling of a curtain over it, and he was sensibly alarmed when he found it could not be removed by rubbing the eye, or by any application he made to it. In a few months afterwards, he was entirely deprived of the use of the eye affected. After some struggles

1. Muncaster Castle

lest his remaining eye should also be attacked, he determined to paint no more. Still, however, he retained his usual spirits, was amused by reading, or hearing others read to him, and partook of the society of friends as formerly. He attended at the Royal Academy with his usual regularity, wearing a green shade over the defective eye; and on the 10th of December 1790, fifteen months after the time when his sight was first affected, he read his last discourse in the Academy, apparently without any difficulty.

In the month of April 1791, he made an exhibition of his pictures by the old masters at a room in the Haymarket, and gave it the title of 'Ralph's Exhibition.' Ralph was the name of a favourite and faithful servant who had lived with him many years, and it was understood that the exhibition was for his emolument. His collection consisted of one hundred and seven pictures, which were described in a catalogue raisonée; and he was amused for some time in preparing it for this public display.

On the 8th of July in the same year, Alderman Boydell, who was then Lord Mayor, gave a grand

Opposite: Mary Stuart, Countess of Bute, 1777-79

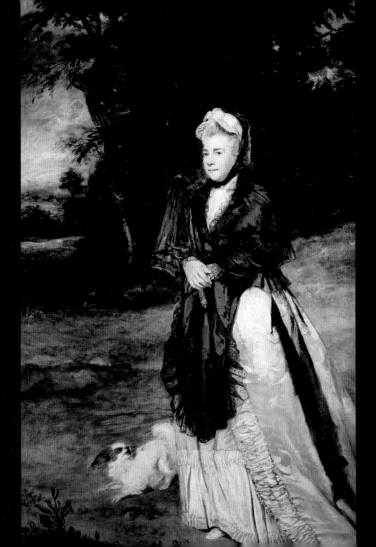

dinner at the Mansion House to the Royal Academi-
cians, which Sir Joshua attended, and participated
in the festivity with his usual cheerfulness.

He thus continued to enjoy society, and Mr.
Malone mentions, that so late as September 1791, he
was in such health and spirits, that, in returning to
town from Mr. Burke's, near Beaconsfield, they
walked five miles on the road without his complain-
ing of any fatigue, and that he had then, though
above sixty-eight years of age, the appearance of a
man not much above fifty, and seemed as likely to
live for ten or fifteen years longer, as any of his
younger friends. But this was only of short duration,
for in the course of the following month, perceiving
indications of a tumour with inflammation over the
eye which had perished, and apprehending that it
might affect the remaining eye, his spirits became
sensibly depressed.

Nearly two years before the period at which the
narrative has now arrived, a circumstance occurred
of some moment, which, as it deeply concerned Sir
Joshua Reynolds as well as the Society of which he
was then the head, should not be passed over un-
noticed, namely, the resignation of that great man as

President of the Royal Academy: more especially as that event excited great public attention at the time, and gave rise to much misrepresentation and obloquy, the effects of which are, perhaps, traceable even at the present moment.

In Mr. Malone's account of Sir Joshua Reynolds, there is, at the conclusion of his comparison of Sir Joshua with the celebrated Roman Lælius, the following passage: 'As Lælius, admired and respected as he was, was repulsed from the consulate, Sir Joshua Reynolds, for a short time, was, by an unhappy misunderstanding, *driven* from the chair of the Academy.'

In recording this unjust accusation against the Royal Academy, Mr. Malone, in the warmth of his zeal for his friend Sir Joshua, departed from his usual prudence and fidelity of statement. The fact was as follows.

By the Laws of the Royal Academy it is ordained, that the several Professorships of Painting, Sculpture, Architecture, and Perspective, shall be filled by Academicians. Samuel Wale held the situation of Professor in Perspective from the establishment of

the Academy, and died February 7th, 1786. It had long been the opinion of the President, and, generally, of the members who at that time formed the Body, that public Lectures on Perspective, especially as, delivered by Mr. Wale, might amuse, but that it was impossible the students should derive any real practical advantage from them. It was a science, they conceived, which could not be communicated by such means. But anxious that the structure of the Institution should not be left incomplete, and at the same time to give all possible efficiency to the different appointments, it was resolved, on announcing the death of Mr. Wale, that only an introductory Lecture should be delivered in public on the subject of Perspective, and that the professor should deliver the remainder in a private and more intelligible manner.

No Academician having presented himself as candidate for the vacant office, Mr. Edwards, an associate of the Academy, offered to teach Perspective to the students by an extended series of private lessons, suspending, or omitting altogether, the public lectures on that subject. The offer of Mr. Edwards was accepted by the President and Council; he accordingly commenced his course of private instructional January 1789, and proceeded

very much to the satisfaction of the Academicians, and benefit of the Students.

It happened at this time that Mr. Bonomi, a native of Rome, and an ingenious architect, had placed his name in the list of candidates for the degree of Associate, from which rank of members the Academicians are elected. The name of Mr. Gilpin, an artist of high celebrity, and universally respected, was also on the list. At the assembly of Academicians to fill the vacancy which then occurred, there was but a thin meeting of members; the numbers on the ballot were equal, and the President gave the casting vote for Bonomi. Sir Joshua thought it necessary however to apologise for the vote he had given, by saying that he had done it 'with a view to Mr. Bonomi's being elected an Academician, in order that he might be appointed professor of Perspective.' The members present were surprised at the inconsistency of the President; and it was

Overleaf: The Academicians of the Royal Academy in the Life Room, 1773, mezzotint by Richard Earlom after Johan Zoffany. Reynolds, holding an ear trumpet, stands near the centre; immediately to his right is Sir William Chambers. Zoffany is at the bottom left, holding a palette. It was in the Life Room that Reynolds' body was laid out before his funeral, despite Chambers' objections

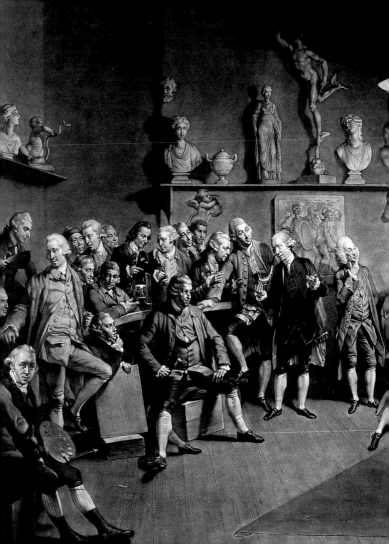

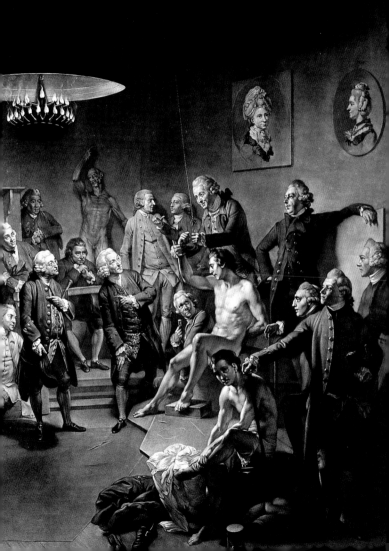

generally believed, that he had been induced to depart from his usual delicacy on such occasions, by his respect for the Earl of Aylesford and some others, who were the avowed patrons of Bonomi.

A vacancy of an academic seat occurring shortly after, Sir Joshua exerted his influence to obtain it for Mr. Bonomi; but Mr. Fuseli's name being then on the list of Associates, a large majority of the members were decidedly of opinion, that his professional ability in the highest line of the art, and highly cultivated talents, entitled him to their votes. Besides, as before shewn, the professorship of Perspective was then looked upon rather as a matter of show than of actual use to the students; and on this account, there was no desire to fill the vacancy, and change the mode of tuition which was pursuing with so much success.

It has been stated above, that the Academicians are elected from the body of Associates, whose claims, being members of the Institution, are supposed to be well known by their works; therefore on days of election, no new specimens of their talents are required or allowed to be produced; and as this rule applies to the whole of the associates, any single one of the number, availing himself of such an

expedient to influence the electors, would be thought peculiarly indecorous. On the 10th of February, 1790, however, when the Academicians assembled for the purpose of electing a new member, they were surprised to see a number of drawings, the work of Mr. Bonomi, prepared for their inspection. How they came there was not explained; but as the offensive novelty could not be permitted, they were immediately removed by vote, and the members proceeded to the ballot, which terminated in favour of Mr. Fuseli, who was elected by a great majority. The election having terminated, the President quitted the chair with evident signs of dissatisfaction.

Although it became known that Sir Joshua Reynolds had calculated upon the success of Bonomi, and that he was mortified by the disappointment, nothing transpired till the 22d of February, when that excellent man, who during twenty-one years had filled the chair of the Royal Academy, with honour to himself, and the highest approbation of the Society, allowed an unjust resentment so far to get the better of his judgment, as to announce his determination to resign his office. The following letter was on that day received by the Secretary.

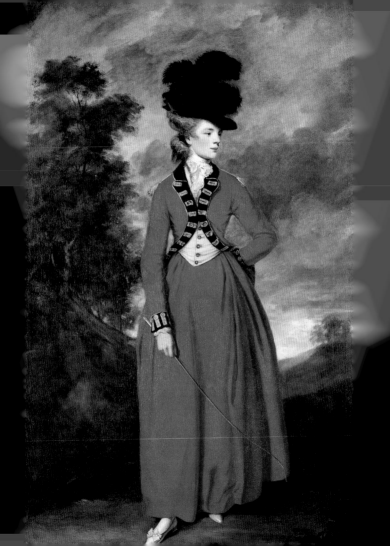

Leicester Fields, Feb. 23. 1790.

Sir,

I beg you would inform the Council, which I understand meet this evening, with my fixed resolution of resigning the Presidency of the Royal Academy, and consequently my seat as an Academician. As I can no longer be of any use to the Academy as President, it would be still less in my power, in a subordinate situation. I therefore now take my leave of the Academy, with my sincere good wishes for its prosperity, and with all due respect to its members.

I am, Sir, your most humble,
and most obedient servant,
Joshua Reynolds.

P.S. Sir William Chambers has two letters of mine, either of which, or both, he is at full liberty to communicate to the Council.

At a Meeting of the Council which followed, this letter from the President was the chief subject of deliberation. Another letter was also produced from

Opposite: Lady Worsley, c. 1776. Reynolds chose this painting to show at the first Royal Academy exhibition in its new home, Somerset House (the rooms shown on p. 94)

Sir William Chambers to Sir Joshua Reynolds, written in consequence of an interview which the former had obtained of His Majesty, expressly, as it appeared, to inform him of what had occurred. Among other flattering marks of the Sovereign's favour, the letter expressed, that His Majesty would be happy in Sir Joshua's continuing in the President's Chair.'

Sir Joshua's letter to Sir William Chambers, in reply, stated in effect, 'That he inferred his conduct must have been satisfactory to His Majesty, from the very gratifying way in which his royal pleasure had been declared; and if any inducement could make him depart from his original resolution, the will of his Sovereign would prevail; but that flattered by His Majesty's approval to the last, there could be nothing dishonourable in his resignation; and that in addition to this determination, as he could not consistently hold the subordinate distinction of Royal Academician, after he had so long possessed the Chair, he begged also to relinquish that honour.'

Opposite: Jane Fleming, afterwards Countess of Harrington, c. 1775. Sister of Lady Worsley (see p. 130), Jane Fleming is shown here not in uncompromisingly modern dress used in her sister's portrait, but as a personification of Aurora in Reynolds' 'Historical Style'.

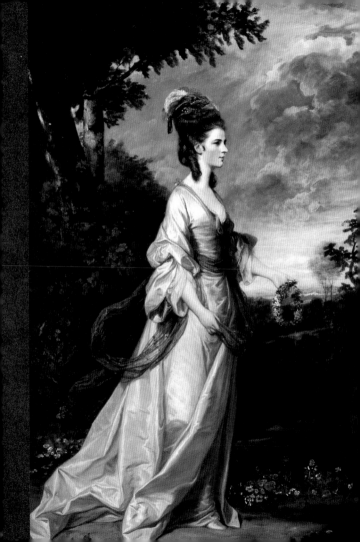

March 3d, a General Assembly of Academicians was called, to confer on the event which had happened. The regret expressed by the members was general and sincere, and a vote immediately and unanimously passed, that the thanks of the Royal Academy be given to Sir Joshua Reynolds, for the able and attentive manner in which he had so many years discharged his duty as President of that Society.' But as any endeavours on the part of the general body, to soothe their late President, appeared equally useless and improper, more especially as he had resisted the wish of the Sovereign, so graciously expressed, it was determined, that a meeting should be shortly called to fill the vacancy which had thus unhappily occurred.

The proposed meeting took place March 13th, and still moved by an anxious desire to conciliate their President, as far as it was possible, consistent with the respect due to themselves and the institution, it was 'resolved, that upon enquiry, it is the opinion of this meeting, that the President acted in conformity with the intention of the Council in directing Mr. Bonomi to send a drawing or drawings to the General Meeting, to evince his being qualified for the office of Professor of Perspective; but the General Meeting

not having been informed of this new regulation of the Council, nor having consented to it as the laws of the Academy direct, the generality of the assembly judged their introduction irregular, and consequently voted for their being withdrawn.'*

This resolution was succeeded by another, namely, 'resolved that Sir Joshua Reynolds's declared objection to his resuming the Chair being done

* It will here be understood, that the Council of the Royal Academy could adopt no measure that would operate on the General Assembly without the formal sanction of that body. But had it been otherwise the Members assembled at this Meeting might with great truth 'Resolve' that they were ignorant of the Order of Council requiring the production of drawings, for there Was, in fact, no regular order, as the minutes fully testify. The General Assembly, however, passed over the irregularity of the proceeding, and possessed with grateful recollections of the wise and beneficial conduct of Sir Joshua through a long series of years, they came to a resolution to endeavour to conciliate him by the mode adopted, which happily had the desired effect.

Nothing further took place respecting the office of Professor of Perspective. Mr. Edwards held the appointment of 'Teacher of Perspective,' giving lessons privately to the Students during the remainder of his life. He died December 19, 1806, and some years elapsed before the vacancy of Professor of Perspective was filled, when in the long interval from the death of Mr. Wale, the Academy was composed of nearly a new body of members, who continued the appointment on the original plan.

away, a Committee be appointed to wait on Sir Joshua Reynolds, requesting him, that, in obedience to the gracious desires of His Majesty, and in compliance with the wishes of the Academy, he would withdraw his letter of resignation.'

It was then determined that these resolutions should be communicated to Sir Joshua Reynolds, by the following Members; namely, Messrs. West, Copley, Farington, T. Sandby, Bacon, Cosway, Catton, and the Secretary.

The above-named delegates accordingly waited upon Sir Joshua, who received them with evident marks of satisfaction. They read to him the Resolutions of the Academy, and stated to him their own and the general wish of the members, that he would reconsider his determination, and consent to resume his situation as President of an Institution of which his talents had been so long an essential support. Sir Joshua, in reply, expressed his gratitude for this honourable proceeding towards him; and said, he should with great pleasure accede to their wishes. He then invited the Committee to dine with him that day, in order to convince them, that he returned with sentiments of the most cordial amity.

To the adjourned Meeting of the General Assembly, the Delegates reported the success of their mission, and announced the agreeable intelligence, that their President would appear in his place the same evening.

Sir Joshua Reynolds attended the meeting, and signified his having withdrawn his letter of resignation; but that he did not think he was authorised to resume the Chair until he had obtained His Majesty's leave.

His Majesty's gracious permission having been received, Sir Joshua again appeared in the President's Chair on the 16th of March, 1790.

Thus happily terminated a misunderstanding which, when first reported, brought upon the Academy much odium, and the strongest expressions of reprobation from the numerous friends of Sir Joshua, who would admit of no reasoning on the subject. The charge of Mr. Malone, that Sir Joshua had been driven from the Academy, shewed to what length unfounded accusation was carried. This unjust accusation from a person of his character, published several years after Sir Joshua's death, is

wholly unaccountable. It would seem that he either thought it impossible his friend could err, or that no irregularity committed by such a man should be resisted; and so much was his habitual diligence of enquiry, and love of truth, overcome in this instance by his strong feelings of respect and admiration, that he neither sought for nor would listen to any statement that proposed to correct his preconceived opinion: although it went to accuse the whole body of Academicians of being guilty of a disgraceful outrage upon an unoffending and illustrious individual.

Though the interval between Sir Joshua's resignation of the presidency and his return to that office in the Academy was only twenty-two days, yet in that short period the prompt zeal of his admirers to offer him their testimonies of respects produced many effusions of their genius both in verse and prose. The Earl of Carlisle sent forth some poetical lines expressing his sympathising regret, and Mr. Edward Jerningham, one of the minor poets of that time, published a violent invective against the Academy as his tribute

Opposite: Giuseppe Baretti, 1773. Part of the Streatham Park circle around Mrs. Thrale, in whose library this portrait once hung. Baretti was Secretary for Foreign Correspondence at the Royal Academy and translated Reynolds' Discourses into Italian

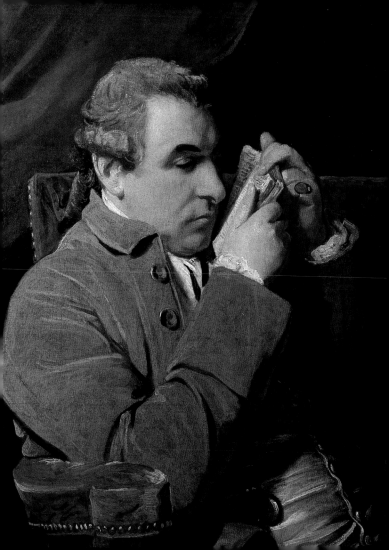

of condolence. Few are disposed to attend to impartial statements in any case, although it be notorious that much misrepresentation abounds in many of the transactions of life, both public and private. There is besides a kind of generosity which inclines us to presume in all disputes between bodies of men and individuals, that the cause of justice is always with the latter. To blame the Academy was therefore the favourite topic of the day, and especially among those who moved in the higher circles of Society.

VERSES

To Sir JOSHUA REYNOLDS

On his late Resignation of the President's Chair of the Royal Academy.

By the EARL of CARLISLE.

Too wise for contest, and too meek for strife,
Like Lear, oppress'd by those you rais'd to life,
Thy sceptre broken, thy dominion o'er,
The curtain, falls, and thou'rt a King no more. —
Still, near the wreck of thy demolish'd state,
Truth and the weeping Muse with me shall wait;
Science shall teach BRITANNIA's self to moan,
And make, O injured Friend! thy wrongs her own.

Shall we forget, when, with incessant toil,
To thee 'twas giv'n to turn this stubborn soil —
To thee, with flow'rs to deck our dreary waste,
And kill the pois'nous weeds of vicious taste;
To pierce the gloom where *England's Genius* slept,
Long of soft love and tenderness bereft;
From his young limbs to tear the bands away,
And bid the *Infant Giant* run and play?

Dark was the hour, the age an age of stone,
When *Hudson* claim'd an empire of his own;
And from the time, when, darting rival light,
VANDYKE and RUBEN cheer'd our northern night;
Those twin stars set, the graces all had fled,
Yet paus'd, to hover o'er a LELY's head;
And sometimes bent, when won with earnest pray'r,
To make the gentle KNELLER all their care:
But ne'er with smiles to gaudy VERRIO turn'd,
No happy incense on his altars burn'd:
O! witness, *Windsor!* thy too passive walls,
Thy tortur'd ceilings, thy insulted halls!
Lo! *England's* glory, EDWARD's conquering son,
Cover'd with spoils from *Poictiers* bravely won —
Yet no white plumes, no arms of sable hue,
Mark the young hero to our ravish'd view;
In buskin trim and laurell'd helmet bright,
A well-dress'd *Roman* meets our puzzl'd sight;

And Gallia's captive King, how strange his doom,
A Roman too perceives himself become!

See too, the miracles of God profan'd,
By the mad daubings of this impious hand;
For while the dumb exults in notes of praise,
While the lame walk, the blind in transports gaze –
While vanquish'd demons Heav'ns high mandates hear,
And the pale dead spring from the silent bier,
With lac'd cravat, long wig, and careless mien,
The Painter's present at the wondrous scene!
VANLOO and DAHL, these may more justly claim,
A step still higher on the throne of Fame;
Yet to the West their course they seem to run,
The last red streaks of a declining sun.

And must we JERVAS name? So hard and cold,
In ermine robes, and peruke only bold;
Or, when inspir'd, his rapt'rous pencil own
The roll'd-up stocking and the damask gown!
Behold a tasteless age in wonder stand,
And hail him the APELLES of the land!
And DENNER too – but yet so void of ease,
His figures tell you — they're forbid to please;
Nor in proportion, nor expression nice,
The strong resemblance is itself a vice;
As wax-work figures always shock the sight
Too near to human flesh and shape, affright
And when they best are form'd afford the least delight.

Turn we from such to thee, whose nobler art
Rivets the eye and penetrates the heart:
To thee, whom Nature, in thy earliest youth,
Fed with the honey of eternal Truth
Then, by her fondling art, in happy hour,
Entic'd to Learning's more sequester'd bower:
There all thy life of honours first was plann'd,
While Nature preach'd, and Science held thy hand —
When, but for these, condemn'd perchance to trace
The tiresome vacuum of each senseless face,
Thou in thy living tints had ne'er combin'd
All grace of form and energy of mind
How, but for these, should we have trembling fled
The guilty tossings of a BEAUFORT's bed;
Or, let the fountain of our sorrows flow
At sight of famish'd UGOLINO's woe?
Bent on revenge, should we have pensive stood
O'er the pale Cherubs of the fatal Wood,
Caught the last perfume of their rosy breath,
And view'd them smiling at the stroke of death?
Should we have question'd, stung, with rage and pain,
The spectre line with the distracted THANE?
Or, with ALCMENA's natural terror wild,
From the envenom'd serpent torn her child?

Overleaf: Ugolino and his sons, 1774, mezzotint by John Dixon after
Reynolds. According to Dante, Ugolino only survived prison by eating
the bodies of his children, at their insistence

143

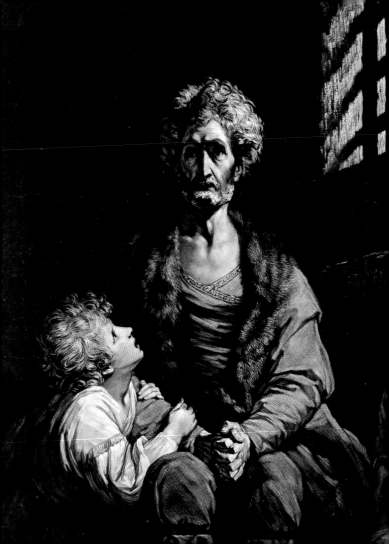

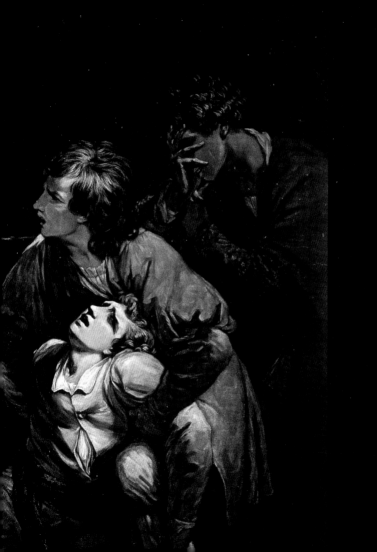

And must no more thy pure and classic page
Unfold its treasures to the rising age?
Nor from thy own Athenian temple pour
On list'ning youth of art the copious store? —
Hold up to labour independent ease,
And teach ambition all the ways to please!
With ready hand neglected Genius save,
Sick'ning, o'erlook'd in Mis'ry's hidden cave;
And, nobly just, decide, the active mind
Neither to soil nor climate is confin'd!

Desert not then my sons; those sons who soon
Will mourn with me, and all their error own.
Thou must excuse that raging fire, the same
Which lights their daily course to endless fame,
Alas! impels them thoughtless far to stray
From filial love and Reason's sober way.
Accept again thy pow'r — resume the Chair —
Nor leave it till you place, an Equal there.

Immediately on Sir Joshua's resignation, the following lines were addressed to him by Mr. Jerningham:

Ye to whose soul kind nature's hand imparts
The glowing passion for the liberal arts;
Ye great dispensers of the magic strain,
Whose harmony delight almost to pain;

Ye to whose touch (with Damer's skill) is known
To charm to life, and wake the sleeping stone;
Ye rare Promithic, to whose hand is given,
To snatch the flame that warms the breast of Heav'n;
Ye too, ye Bards, illustrious heirs of fame,
Who from the sun your mental lineage claim;
Approach and see a dear and kindred art,
Unhallow'd maxims to her sons impart;
See her (become wild faction's ready tool)
Insult the Father of the modern school.
Yet he first enter'd on the barren land,
And rais'd on high Armida's powerful wand:
From him the Academics boast a name,
He led the way, he smooth'd their path to fame;
From him th' instructive lore the pupils claim'd,
His doctrine nurtur'd, and his voice inflam'd!
Oh! and is all forgot? The sons rebel,
And Regan-like, their hallow'd sire expel.
Cou'd not his faculties, so meekly borne,
Arrest the hand that fix'd the rankling thorn?
Cou'd not the twilight of approaching age,
The silver hairs that crown'd th' indulgent sage,
Domestic virtues, his time-honour'd name,
His radiant works that crowd the dome of fame;
Say, cou'd not these suppress the opprobrious scene,
And charm to slumber academic spleen?
Mark, mark the period, when the children stung
The parents' feelings with their serpent tongue;

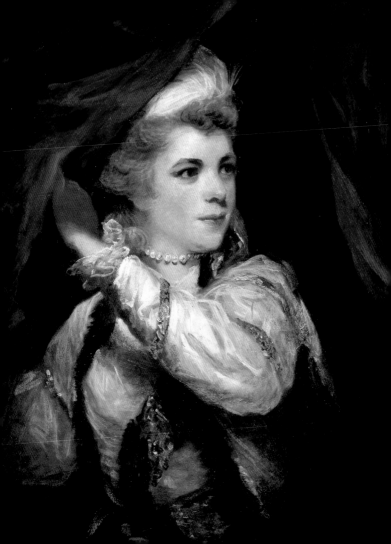

It was while dimness veil'd the pow'rs of sight
And ting'd all nature with the gloom of night.
(Not many days remov'd) the master came
With wonted zeal to touch the swelling theme!
The pregnant canvas his creation caught,
And drank his rich exuberance of thought;
Deck'd with the beams of inpiration's sky,
Glanc'd o'er the work his finelyfrenzy'd eye.
— Malignant fate approach'd — the scenes decay,
To him the new creation fades away;
Thick night abruptly shades the mimic sky,
And clouds eternal quench the frenzy'd eye!
Invention shudder'd — Taste stood weeping near —
From Fancy's gush'd the glitt'ring tear —
Genius exclaim'd — 'My matchless loss deplore,
The hand of Reynolds falls, to rise no more!'

Tranquillity being thus restored in the Royal Academy, Sir Joshua Reynolds continued his unremitted attention to the duties of his office, till finding the complaint in his eyes increase, and daily expecting the total loss of sight, his resignation seemed to be indispensable. He appeared in the Academy for the last time at a Meeting of the Council, on the 25th of June, 1791; and at a General

Opposite: Mrs. Abington as 'Roxalana', 1782-83

Assembly, held on the 10th of November in that year, Mr. West desired the attention of the Assembly to the reading a letter he had just received from the President; and was as follows:

> Dear Sir,
>
> I must request the favour of you to supply my place at the General Meeting held this evening. I beg at the same time, that you will acquaint the Academicians, that however desirous I am, and ever shall be, to contribute every service in my power towards the prosperity of the Academy, yet, as I feel myself incapable of serving the office of President for the ensuing year, I think it necessary that this should be declared at the present Meeting, that the Academicians may have time to consider between this and the 10th of December of a proper successor.
>
> I am, with great respect,
> Your most obedient Servant,
>
> Joshua Reynolds.

No proceeding in the Academy took place in consequence of this letter being read, as it was the general sentiment of the members, that Sir Joshua should continue to hold the office of President, and

appoint a Deputy to act for him at the usual Meetings of the Society. Accordingly, on the 10th of December, the day when the annual officers are elected, he was returned as usual. Sir Joshua being thus re-elected President, Sir William Chambers, or Mr. West, were his Deputies at subsequent meetings. But the Academy, did not long possess their President even in this imperfect state, for the disease with which he had been sometime afflicted, now made rapid progress, and on the 23d of February, 1792, between eight and nine in the evening, this great artist, and exemplary man, paid the last awful debt to nature, in the 69th year of his age.

For some time before his death, his illness produced a melancholy which was the more distressing to his friends, as it was indulged in silence. For some weeks before his death, his spirits were so low, that he was unable to bear even the consolations of friendship. The numerous attentions of many of the nobility and men of science, during his illness, were the best testimony of the value set upon him, and of the regret with which they contemplated his illness, and predicted his dissolution. 'His illness,' said Mr. Burke, 'was long, but borne with a mild and cheerful fortitude, without the least mixture of any thing

irritable or querulous, agreeable to the placid, and even tenor of his whole life. He had, from the beginning of his malady, a distinct view of his dissolution, which he contemplated with that entire composure, which nothing but the innocence, integrity, and usefulness of his life, and an unaffected submission to the will of Providence, could bestow.'

Upon Sir Joshua's decease, the Council of the Royal Academy received from Messrs. Burke, Metcalf, and Malone, the three executors, the following propositions respecting the funeral of Sir Joshua Reynolds; viz.—

That it is the wish of the Executors of Sir Joshua Reynolds, that the body be conveyed to the Royal Academy the evening before the interment, and the friends who attend him to be admitted to proceed from thence.

They leave to the Royal Academy to consider of the propriety of inviting such persons of distinction as used to attend their annual meetings, such as Ministers of State, Foreign Ministers, Presidents of Societies, &c. &c. as they think proper.

Sir Joshua's Undertaker to wait on Sir William Chambers, to receive the instructions of the

Council, for the provision of coaches for the
Academy, cloaks, &c. &c.

This was instantly agreed to by all present, except
Sir William Chambers, who reminded the Council,
that he was by His Majesty appointed Surveyor of
the Building, and was bound not to permit its being
used for any other purposes than those specified in
the grant, which runs thus: '*That the Academy cannot let
or lend any part thereof, for any other purpose than that to
which it is appropriated.*' 'It therefore appears,' said Sir
William, 'that however desirous we were to shew
such a mark of respect to our late President, we were
not in possession of the power.'

However unprepared and disappointed the
Members of the Council were by this unexpected
obstacle, they judged it proper to submit to the
objection stated by Sir William Chambers, acting
under the Royal Authority, and a letter was written
to the Executors to that effect.

The report of what passed in the Council quick-
ly spread among the Academicians, and the expres-
sions of disappointment and concern being general,
Mr. West undertook to state to His Majesty all the

circumstances respecting the application of the executors. The result was, that at a General Assembly held February 28th, Mr. West informed the Members that he had communicated to His Majesty the proposals received from the Executors of Sir Joshua Reynolds, and of the answer which had been returned, which he entirely approved, but it was his Royal pleasure that the wish of the Executors should be complied with. Having thus obtained His Majesty's gracious sanction, a deputation of Members immediately waited on the Executors, and it was agreed that the body should be removed to the Academy; that one of the apartments should be hung with black, and otherwise prepared to receive it in the customary form; and also, that the order of procession to the place of interment should be settled conformable to the advice of the Herald's Office.

Some doubts having arisen in this conference respecting the place proper to be taken by the Members of the Academy in the procession, the

Opposite: Sir William Chambers, 1780, mezzotint by Valentine Green after Reynolds. The new premises of the Royal Academy, designed by Chambers as part of the new Somerset House, are shown in the background

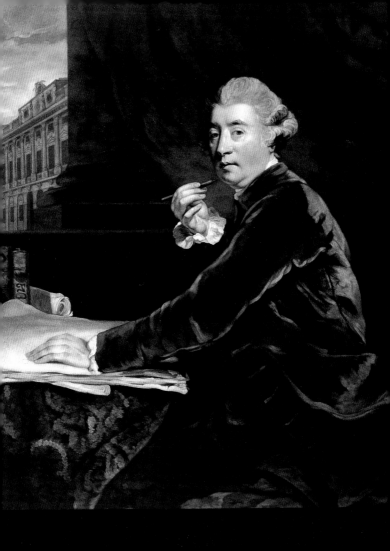

Executors left that point to be decided by themselves. It was therefore determined that the general body of Members of that Institution, Academicians, associates, and also the Honorary Officers, should follow the body of their illustrious President after the pall-bearers, his own family, and his Executors.

Agreeable to what had been determined, the body was conveyed on the evening of March 2nd, 1792, to the Royal Academy; and there, at half past ten o'clock the next morning, the several persons who were to attend the funeral, assembled.

So early as nine o'clock that morning, the Peace Officers were placed at the corner of each street leading to the Strand, Fleet Street, or Ludgate Hill, in order to prevent all carriages, during the course of the morning, from driving along either of those streets. All carriages during this morning, from the west end of the town, which were going into the city, passed along Holborn and Newgate Street. From ten o'clock all, the shops between Somerset House and St. Paul's were shut up, and the whole space between Temple Bar was crowded with innumerable persons waiting to see the funeral obsequies; and from that hour till twelve, the streets were filled with the

mourning coaches coming to Somerset House, and with the carriages of the nobility and gentry, conveying to that place those who were invited to attend the funeral.

The friends of Sir Joshua who attended on this occasion, assembled in the library and council-chamber of the Royal Academy; and the Academicians, associates, and Students, in other apartments of that edifice.

At a quarter past twelve, the coffin was put into the hearse. The company were conveyed in forty-two mourning coaches; and forty-nine coaches belonging to the Noblemen and Gentlemen attended.

It has been truly said, 'that never was a public solemnity conducted with more order, decorum, and dignity.' The procession set out at half an hour after twelve o'clock. The Lord Mayor and Sheriffs honoured the procession by coming to Somerset Place, where an officer's guard of thirty men was placed at the great court gate. After the procession had passed through Temple Bar, the gates were shut by order of the Lord Mayor, to prevent any interruption from the passing of carriages to or from the city by that avenue.

The spectators, both in the hurch and in the street, were innumerable. The shops were shut, the windows of every house were filled, and the people in the streets, who seemed to share in the general sorrow, beheld the whole with awful respect and silence.

The order of the procession was as follows:—

City Marshal and his men
The Lord Mayor
The Sheriffs



Lord Elliot
Earl of Upper Ossory
Earl of Carlisle, K. T.
Marquis Townshend, K. G.
Duke of Leeds,

 THE BODY.

Viscount Palmerston
Earl of Inchiquin, K. P.
Marquis of Abercorn
Duke of Portland
Duke of Dorset, K. G.



Chief mourner—Mr. Gwatkin, Sir Joshua's nephew by marriage
Mr. Marchi, who came from Italy with Sir Joshua
Ralph Kirtley, Sir Joshua's old servant

Executors
Edmund Burke, Esq., Edmund Malone, C. Metcalfe, Esq

The Council of the Royal Academy
E. Catton, Esq. — Henry Fuseli, Esq.
Joseph Nollekens, Esq. — Benjamin West, Esq.
John Webber, Esq. — John Yenn, Esq.
Thomas Sandby, Esq. walked as Professor of Architecture

Officers of the Royal Academy

Jos. Wilton, Esq. Keeper — Sir William Chambers, Treasurer
John Richards, Esq. Secretary — Dominick Serres, Esq.
Librarian

Professors in the Royal Academy

Thomas Sandby, Esq. Professor of Architecture
James Barry, Esq. Professor of Painting
Bennet Langton, Esq. Professor of Ancient Literature
J. Boswell, Esq. Secretary for foreign correspondence

Academicians

John Bacon, Esq. — Thomas Banks, Esq.
Francesco Bartolozzi, Esq. — Edward Burch, Esq.
John Singleton Copley, Esq. — Richard Cosway, Esq.
George Dance, Esq. — Joseph Farington, Esq.
William Hamilton, Esq. — William Hodges, Esq.
T. P. de Loutherbourgh, Esq. — Francis Milner Newton, Esq.
James Northcote, Esq. — John Opie, Esq.
John Francis Rigaud, Esq — — Russell, Esq.
Paul Sandby, Esq. — William Tyler, Esq.
James Wyatt, Esq. — Johan Zoffany, Esq.

Associates

Mr. Rebecca — Mr. Rooker
Mr. Edwards — Mr. Nixon
Mr. Hone — Mr. Bourgeois
Mr. Bigg — Mr. Bonomi
Mr. Lawrence — Mr. Smirke
Mr.Stothard — Mr. Marchant
Mr. Tresham

Associate Engravers
Mr. Green — Mr. Collyer
Mr. Heath — Mr. Brown

Artists, not Members of the Royal Academy
Students
Mr. Thomas Cheesman — Mr. Richard Duppa
Mr. I. Saunders — Mr. Martin Archer Shee
Mr. Collins — Mr. Bowyer
Mr. Burch — Mr. Hickey
Mr. Shelly — Mr. Wood

Noblemen and Gentlemen who attended the Funeral
Archbishop of York
Marquis of Buckingham
K. P. Earl of Carysfort — Earl of Fife
Bishop of London
Viscount St. Asaph
Lord Fortescue — Lord Somers
Lord Lucan
Dean of Norwich
Sir George Beaumont — Right Hon. William Windham
Sir Abraham Hume — Sir Charles Bunbury, Bart.
Sir William Forbes, Bart. — Sir Thomas Dundass, Bart.
John Rolle, Esq. M.P. — Sir William Scott, M. P.
Matthew Montague, Esq. — William Weddell, Esq.
Richard Payne Knight, Esq. M.P. — Reginald Pole Carew, Esq. M.P.
George Rose, Esq. M. P. — Dudley North, Esq. M. P.
Abel Massey, Esq. — John Cleveland, Esq. M. P.
Alderman John Boydell, Esq. — Alderman Rd. Clarke, Esq.
Charles Townley, Esq. — Dr. Laurence, of the Commons.
Captain Pole — Colonel Gwyn
Wellbore Ellis Agar, Esq. — Edward Jerningham, Esq.

John Thomas Batt, Esq. — Richard Burke, Esq.
William Seward, Esq.—John Hunter, Esq., the celebrated Surgeon
John Julius Angerstein, Esq. — Charles Burney, Esq. Mus. D.
— Coutts, Esq. — William Vachel, Esq.
— Home, Esq. — — Martin, Esq.
John Devaynes, Esq. — William Cruikshank, Esq.
John Philip Kemble, Esq. — Joseph Hickey, Esq.
Mr. Poggi — — Drew, Esq.
Mr. Breda, &c. &c

The hearse arrived at the great western gate of St. Paul's about a quarter after two o'clock, and was then met by the dignitaries of the church, and by the gentlemen of the choir, who chaunted the proper psalms, whilst the procession moved to the end of the choir, where was performed, in a superior manner, the full choir evening service, together with the celebrated anthem of Dr. Boyce; the body remaining during the whole time in the centre of the choir.

The chief mourner and gentlemen of the Academy, as of the family, were placed near the body. The chief mourner in a chair at the head, the two attendants at the feet, the pall-bearers and executors in the seats on the decanal side, and the other noblemen and gentlemen on the cantorial side. The Bishop of London was in his proper place, as were the Lord Mayor and Sheriffs.

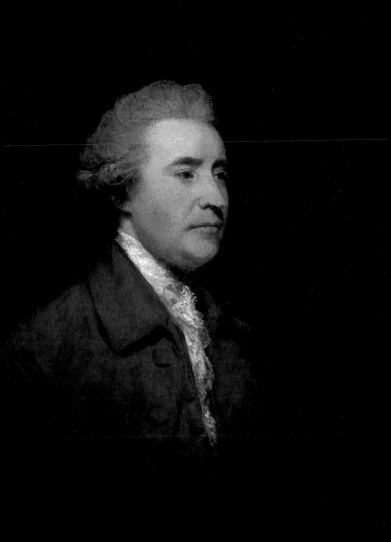

After the service, the body was conveyed into the crypt, and was placed beneath the brass plate under the centre of the dome. Dr. Jefferies, Canon Residentiary, with the other Canons, and the Pall-bearers, Executors, Academicians, and the whole choir, walking two by two, formed a circle under the dome; the grave-digger attending in the middle with a shovel of mould, which at the proper time was thrown through the aperture of the plate, on the coffin. The funeral service was chaunted, and accompanied by the organ in a grand and affecting manner. When the funeral service was ended, the Chief Mourners and Executors went into the crypt, and attended the corpse to the grave, which was dug under the pavement. The body was interred close adjoining the grave of Sir Christopher Wren.

The procession then returned in nearly the same form to the Royal Academy, and the last carriage reached that place at half an hour past four: and it was not till then, that the gates of Temple Bar were thrown open. At the conclusion of the ceremony, Mr. Burke entered the room where the Academicians were assembled, to express, in the name of the Family

Opposite: Edmund Burke, 1774, among Reynolds' closest friends

and Executors, their thanks to the Academy for their
respectful homage to the deceased; but was prevented
by his feelings from saying more than a few words; he
shed tears and departed.

The Academic Body then resolved, that their
humble and dutiful thanks be offered to His Majesty
'for his gracious permission to gratify their ardent
wishes to do honour to their late President Sir
Joshua Reynolds, and for enabling them, by a splen-
did concurrence with the efforts of his Executors, to
gratify the wishes of the public.' Which resolution
Mr. West was desired to present to His Majesty.

The following Address of Thanks was then
voted to the Lord Mayor and Sheriffs for their
great attention.

The Members of the Royal Academy beg leave to
express their warmest thanks to the Lord Mayor
and Sheriffs, for their personal attendance, and
their successful regulations in preserving order
and decorum during the funeral ceremony of
their late worthy President Sir Joshua Reynolds,
and for this honour and distinguished attention to
the liberal arts.

Finally it was resolved, that the Members of the Academy should continue to wear mourning during one month from that time.

Thus were deposited the venerable relics of Sir Joshua Reynolds, doubly hallowed by a nation's respect, and by the tears of private friendship. The manifestation of the general wish to do honour to his memory, has been fully shewn. The assemblage of so many persons of the highest rank, and of those who were most admired for their talents, and reverenced for their virtues, uniting to pay their respectful homage to departed excellence, may with grateful feelings be recorded as a lasting proof of the high esteem in which he was held, by the most refined classes of society; and the decorum of the public on the solemn occasion, was not less honourable to the deceased than to the state of popular feeling.

The mortal remains of Sir Joshua Reynolds having been deposited in their place of rest, the void which his departure suddenly caused in a very large circle of friends and admirers, seemed at first to be an irreparable calamity; the deep regret, therefore, for the loss of an artist whose works had so long been a source of delight, and whose character was so pure

and refined as to be a pattern to society, naturally occasioned many expressions of the common feeling to issue from the press, which appeared either in the daily journals, or other channels of public communication. Some of these effusions, which have been thought worthy of preservation, will be here given, not on account of any literary or critical merit which they may possess, but as truly expressing the sentiments which generally prevailed in the metropolis and country on the recent misfortune.

———

From the General Evening Post, Feb. 25. 1792.

SIR JOSHUA REYNOLDS.

On Thursday last died this great and excellent man. His genius was not merely confined to his own peculiar art, for his talents were various. He was the first of painters because he chose to be so; he might have stood with Burke in oratory, or Malone in criticism and elegant literature, if to do either had been his object.

His compositions, chiefly discourses on the art he professed, are marked with an Attic elegance of expression, perhaps the result of the harmony

of his mind. Shakespeare owes to him some very beautiful elucidations; and his country, her school of painting. As long as taste shall pursue with delight the progress of the arts, so long shall the name of Reynolds be revered, when even the best specimens of his skill are faded and gone, and the graver presents only the grace with which he was wont to invest what ever came before him.

Virtue, after all, will pour the best praise. He was a firm and faithful friend; and in mixed life a benevolent and honourable man.

As the possessor of an elegant and lovely art, something may be requisite that may discriminate his merits; and when it is ascertained what standard he had himself assumed, as the criterion of excellence, the reference of his own works to that test will prove how far he had attained the perfection he conceived.

If we are to judge from his discourses, of the sentiments he entertained respecting the great masters, Michelangelo appears to have been the god of his idolatry. His style seemed to swell with the fullness of his mind, when he treats of the grandeur of that artist's conceptions. Raphael the President points to as the model of perfect outline, who gives the happiest contour to his objects. Titian he perpetually recommends for the

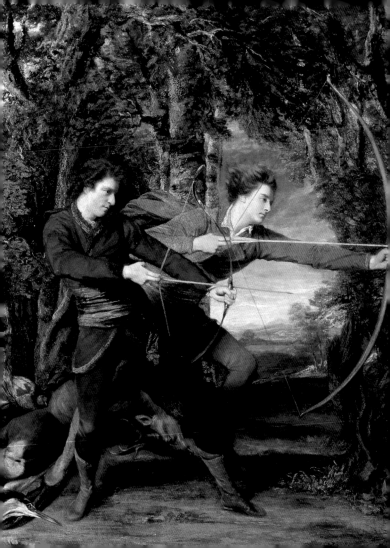

harmony of his colours, and their approximation to nature, in the truth and firmness of his masses.

We have perpetually lamented, that what is technically called the Vehicle should have led him to chemic experiments, which, whatever brilliancy they may lend his colours for the present day, certainly will add to the fading powers of time upon the finest tints.

His living admirers contemplate, with astonishment, the lucid transparency of his colouring; posterity will be confined to the admiration of his unequalled grace in the disposition of his objects. His later works are, we believe, more secure and stable than his earlier.

When Sir Joshua taught us how to paint, there were no historic works which called upon the painter's skill — for, a true taste was wanting: — vanity, however, was not wanting; and the desire to perpetuate the form of our self-complacency crowded his sitting-room with women, who would be transmitted like angels, and men who would be habited like heroes — there they were sure to be contented; the apotheosis was the simple operation of the Painter's mind, glowing with grandeur and with grace.

Opposite: Colonel Acland and Lord Sydney, 'The Archers', 1769, inspired by Reynolds' admiration for Titian

Unhappily, therefore, history has not sufficiently occupied his pencil:— yet he has left us such specimens of what he was competent to, as will long be the boast of the English school — the *Ugolins*, the *Beaufort*, &c.

His very portraits are indeed historic, or rather perhaps epic – there is always business, mind, character, and individuality — yet the combined *whole* first seizes you.

So much it may be sufficient, in passing, to have dilated upon his art, a few words shall be added of his character, in which, truth to say, there was no art. He was the centre of many an ingenious society, and happy were those societies; for their centre was goodness. The conciliating mildness of his manners often united the discordant, and reconciled the discomfited. If we were required to mention the man of our times most be loved by the great and the learned, the ingenious and the polite; we should, without hesitation, notwithstanding academic contests, have named Sir Joshua Reynolds.

He had not completed his 69th year when he was taken from the world which admired him, and the nation to which he was an honour.

Opposite: Augustus, 1st Viscount Keppel, 1781-83

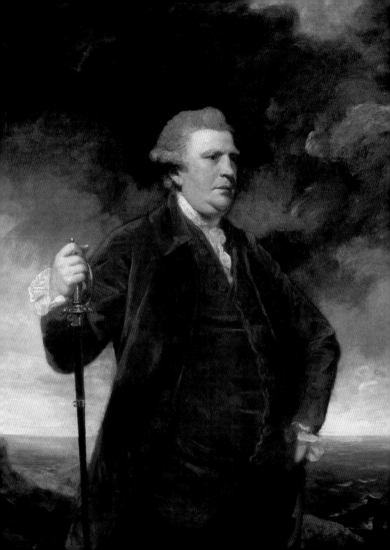

JOSEPH FARINGTON

From the Public Advertiser.

EPITAPH ON SIR JOSHUA REYNOLDS.

From marble monuments, and sculptured arms,
One mournful truth th' observant mind discerns;
Howe'er by genius fir'd, however cast,
To one complexion we must come at last!
The scire of science, and the Artist's friend,
As here entomb'd, but marks one common end;
Yet that his name the mortal wreck may brave,
Affords some consolation in the grave;
That when his frame be moulder'd into dust,
*Or time have dinged o'er this chisel'd bust,**
The finish'd picture, from great Reynolds's hand,
A lasting record, shall his fame demand;
To after ages shall his paintings shew,
How genius colour'd, and how nature drew:
Till mellowing time the Artists self display,
A perfect portrait at the judgment day.

From the same.

One may say of our departed Sir Joshua Reynolds, what Seneca said of a great painter of his time, as thus translated:

* Supposing a bust of Sir Joshua placed on his tomb.

When thy fair soul, by ev'ry virtue led,
 To the bright source of grace and grandeur flew,
Painting herself, her face with tears o'erspread,
 Quick on the ground her brush and palette threw.
These, these, said she, I'll call my own no more;
My fav'rite son, my Reynolds is no more!'

From the same.

Impromptu, by a gentleman attending the funeral of Sir Joshua Reynolds, in St. Paul's Cathedral, where Sir Anthony Vandyke was also interred, in (old) St. Paul's, anno 1641.

Alike in genius, and alike in worth,
 To their deserts a kindred flame was giv'n,
Their faded forms together rest in earth.
 And in one flame their souls unite in heav'n.'

From the Morning Herald.

MONODY
TO THE MEMORY OF
SIR JOSHUA REYNOLDS.

While the pure flame that burns upon the lyre,
Around the heart, and lights the sacred fire,
Heav'n with our hopes has mix'd the cup of fear,

And dash'd the reeking censer with a tear.
Flow, limpid tear, Piérian maidens mourn!
And thou, O Genius! grasp the silent urn.
Let science, pointing with her finger, till,
That Taste turn'd pale when classic Reynolds fell;
Fate, though remorseless, heav'd a solemn sigh,
And Art stood trembling for futurity.
Seiz'd with dismay no more the Graces smil'd
And nature shudder'd for an only child.
Yes, child of nature, on thy pencil hung
The force of Genius, with the Muse's tongue.
What Fancy form'd thy glowing thoughts could reach,
And give the canvas every pow'r but speech.
Learning invidious of the darling son,
Op'd all her stores, and made you half her own;
To Nature's pencil join'd her classic store;
The Muses wept that Knowledge knew no more:
Through life they prais'd thee and lament thy fall;
And weep as niggards, though they gave thee all;
How oft has fancy from the cradle ran,
A present earnest of the future man!
How oft has genius mark'd the early way,
To all the bright maturity of day!
The infant smile, the countenance sincere,
The soul awaken'd to the tender tear,
The heart with, young ambition taught to glow,

Opposite: 'Perdita', 1783-84, (Mrs. Robinson, authoress of the Monody*)*

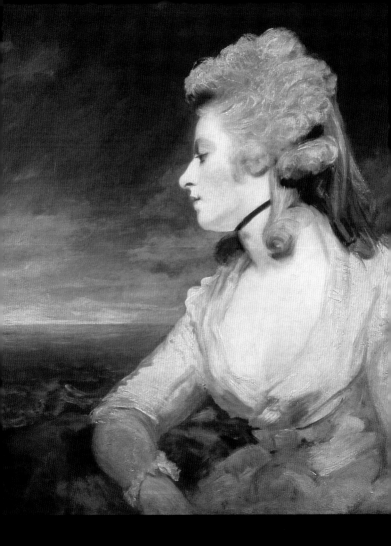

Or gently melting at the tale of woe;
The eye that answers ere the story's told,
The certain presage of superior mould:
Time clasps his fondling, and with pleasure sees,
To manhood rais'd, an infant Hercules.
Thy early pencil mark'd thy future fame,
When science trod where dawning genius came;
Attentive Reason view'd the sober part,
And Merit bade you to command the heart.
Garrick stood fix'd, enchanted to your will,
(The only time that Garrick could stand still):
Johnson with pleasure view'd thy well-earn'd bays,
And stamp'd thy sanction with the nod of praise.
Hail matchless trio, Britain's boast and pride!
By worth united, and in wit allied.
Each taught the world what tutor'd Genius gave,
And each descended honour'd to the grave.
Thro' moral life the weary Rambler past,
And found the peaceful sepulchre at last.
The Actor, form'd by nature to excel,
Stoop'd to Fate's exit – and the curtain fell.
Reynolds remained their friendship to deplore,
'Now Ugolino's sorrows are no more.'
The easy flow that marks the Roman school,
Where thought unfetter'd knows no silken rule;
The touch of Raphael that conveys a mind,
The grace of Titian waving unconfin'd;
Correggio's ease, and Guido's modest air,

With Buonaroth as a polar star.*
These set aloft on Painting's matchless throne.
He scorn'd to copy — yet he made his own,
To Rubens' tints he gave a beauteous hue,
And added charms that Rubens never knew;
Warm'd the plain canvass with a thought unknown,
And with the picture's fame affix'd his own.
Farewell, thou first that Britain's school can boast,
From Genius parted, and to science lost.
May every laurel Reynolds planted grow,
With head reclin'd, the cynosure of woe:
Each leaf shall catch the morn's soft breathing dew,
And drop it on the grave as tears for you.
Perhaps, in future times, some Bard may say,
Beneath this sod, the British Zeuxis lay.
Here fix'd by Fate's irrevocable doom,
Mould'ring in dust is Reynolds' sacred tomb.

From the Gentleman's Magazine.

EPITAPH ON SIR JOSHUA REYNOLDS.

Thine Reynolds was the power, and thine alone,
 To seize the varying form of every grace,
To add, to nature, spirit all thine own,
 And show the mind, resplendent on the face!

* Vide Sir Joshua's last Lecture.

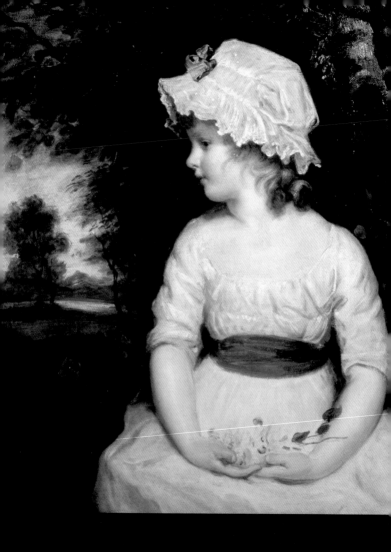

How strong thy pencil when it warn'd the heart,
 By portray'd horrors of the guilty breast!
How soft, how sweet, how delicate its art,
 When infant innocence its charms express'd!

When aged beauty hallows from her shrine,
 The glowing touches of her magic hand,
What hues ethereal, and what fire divine,
 At once our wonder and delight command!

Imagination, skill, and knowledge join'd,
 What could escape thy eye, elude thy art?
What radiant form, or what celestial mind,
 Transcend the virtues of the hand and heart?

Yes, though thy genius glanc'd from earth to Heaven,
 And caught bright glimpses ev'n of things divine;
Yet to a mortal hand 'twas never given
 To trace the seraphs' form which now is thine.

ON THE DEATH OF SIR JOSHUA REYNOLDS

'Reynolds dead!' cries busy Fame;
 A Bard replies, 'that cannot be;
Reynolds and nature are the same,
Both born to immortality.'

Opposite: 'Simplicity' (Theophilia Gwatkin, Reynolds' niece), c. 1785

In a former part of this narrative, it has been shown to what a low state the arts had fallen in this country at the period when Sir Joshua Reynolds commenced his studies; but that, from the same point of time, there has been a growing disposition in the public in favour of the fine arts, and many efforts have been made for their benefit. Encouraged by this inclination, so strongly and so frequently manifested, especially in the upper classes of society, Sir Thomas Bernard, whose mind was often employed in devising means for general or particular improvement, conceived the idea of a society which should have for its object the encouragement of art by enabling Artists to dispose of their works to the best advantage. Having communicated his thoughts to several Noblemen and Gentlemen, known patrons and lovers of the arts, the plan of an establishment to be called the British Institution was formed; and being submitted to His Majesty, he was graciously pleased to approve it, and to declare himself patron. The Prince of Wales, equally disposed with his Royal Father to sanction an undertaking which promised to be of public advantage, was pleased to become its Vice Patron and President. The expense attending the foundation of this Institution was defrayed by the contributions of

individuals, and the list of subscribers comprehended the names of His Majesty, of the Prince of Wales, the whole of the Royal Family, and a large number of nobility and gentlemen.

The chief feature of the plan was an annual exhibition, to consist of the works of living British Artists offered for sale. The Institution was established June 4th, 1805, and the first exhibition opened January 18th, 1806.

The profits arising from the money paid for admission to the exhibition, and from the sale of catalogues, being added to that obtained by subscription, has been occasionally employed in purchasing such pictures by British Artists as have been judged to have sufficient merit to be entitled to marked distinction; in order to encourage others in their exertions.

After a few years had passed away, during which time the Institution proceeded with success, it occurred to the directors that it might be very desirable if an exhibition could be formed, that should consist entirely of the works of Sir Joshua Reynolds. Such a display they conceived would be a high

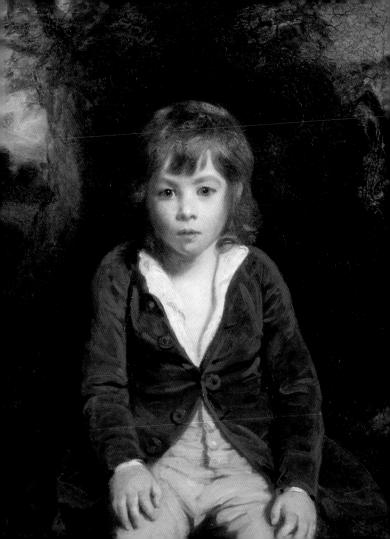

gratification to the public, and equally delightful and advantageous to Artists. Great exertions were accordingly made to procure the finest examples of his productions that could be obtained, and the several proprietors of them complied most liberally with the wishes of the directors.

The number of pictures exhibited amounted to one hundred and forty-two. When the arrangement of works was completed, the exhibition was preceded by a grand commemoration dinner, which took place on Saturday, May 8th, 1813, at the British Institution. The Prince Regent (the President of the British Institution) had announced his intention of honouring the dinner with his presence. His Royal Highness arrived at the British Gallery at five o'clock to view the exhibition, and he was graciously pleased to express, the highest admiration, both of the pictures and their arrangement. A short time before seven, the Regent was conducted from the Gallery by the Marquis of Stafford, through a temporary covered way to Willis's rooms. The Prince Regent sat as President of the British Institution,

Opposite: Master Bunbury, 1781, one of the paintings chosesn for the British Institution exhibition of 1813. The sitter was Reynolds' godson, and the painting may have been made for his own pleasure

having a bust of Sir Joshua Reynolds placed behind him. The Marquis of Stafford on the left hand of the Prince Regent, and, as Deputy President, he officiated, giving the toasts, &c.

His Royal Highness the Duke of Cumberland's band was stationed in an adjoining room, and performed several select and appropriate pieces during and after dinner. To 'the memory of Sir Joshua Reynolds' was a toast drank with enthusiasm and feeling.

About half past nine the Prince Regent left the dining-room, and was reconducted by the Marquis of Stafford to the gallery, which was lighted up on the occasion. The brilliancy and rich harmonious colouring of Sir Joshua's pictures, which sparkled on the walls, — the elegant assemblage of animated beauty who graced the evening show, the great number of the nobility, statesmen, and other distinguished persons of rank, consequence, and intellectual attainments, that were assembled with their Prince, to be delighted, and to honour the memory of the illustrious dead, gave the whole a most fascinating and grand effect. It was, indeed, 'the feast of reason, and the flow of soul.'

Sir Joshua Reynolds had been dead more than twenty years, and almost a new generation had risen up, whose taste had been formed upon works that had been exhibited to the public since his time. The majority of spectators were but imperfectly acquainted with his works, and such an accumulation of splendid art had been seen by none; it is not wonderful, therefore, that this magnificent display should have operated so powerfully. The public prints became the vehicle of declamatory and critical praise, of which some idea may be formed by the specimens here quoted. The following observations were published soon after the Exhibition was opened.

Morning Post, May 13th, 1813.

THE BRITISH INSTITUTION. COLLECTION OF SIR JOSHUA REYNOLDS'S PAINTINGS.

Yesterday will long remain memorable in the annals of the British Arts, from its opening to the view of the public, the paintings of the brightest ornament of our national school, liberally contributed by the various possessors, to be exhibited

Overleaf: The Ladies Waldegrave, 1780-81. Painted for their uncle, Horace Walpole. Exhibited at a second British Institution exhibition in 1823

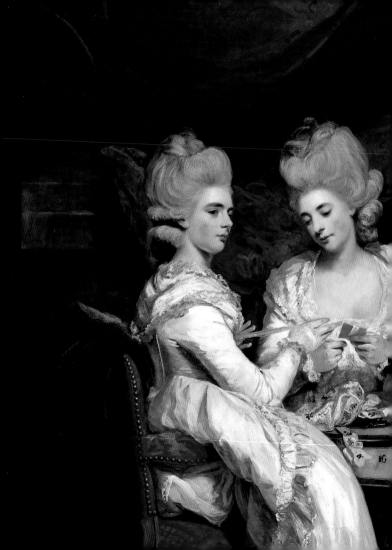

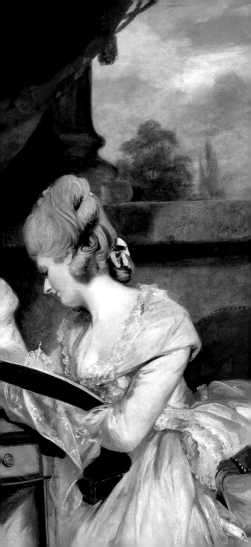

in honour of his memory, and for the benefit of the fine arts in general. Never before, we will venture to say, in this, or in any other nation, was so proud a monument reared by one man, as is here erected to the honour and character of his country, by Sir *Joshua Reynolds*. The dictionary of praise would be exhausted before we could express the pleasure we experienced in viewing this noble collection. We have seen, and seen with wonder, many splendid galleries, containing selections from all the great masters, and have wondered in rapture from gazing on the pure and sublime outlines of *Angelo*, to contemplate *Correggio*, to repose on the mellow tints of *Titian*, to dwell on the splendour of *Paul Veronese*, to admire the gorgeous colouring of *Rubens*, to relax in the characteristic merriments of *Teniers*, and, in fine, to gather enjoyment from the beauties of the several famous schools in Europe,

From grave to gay, from lively to severe!

But never till now did we taste all this variety of gratification springing from one source; the amazing work of one mighty hand. It is impossible to describe the sensations with which the mind is overwhelmed on entering the *British Gallery*. The senses at first refuse to grasp at the large prospect of delight, and the earliest emotions are those of

confusion and disorder. But we come by degrees to be reconciled to the magic that surrounds us, and go from room to room, and from picture to picture, experiencing all the diversity of grateful sensations, which so interesting a spectacle is sure to produce. To endeavour in this paper to communicate any idea of these would be vain; we therefore confine ourselves to the general statement in saying, that here is provided full of the dearest recollections to our elder artists;— full of instruction to their juniors, in tracing a *Reynolds* through a course of forty years — full of national glory, and fraught with unmeasurable pleasure to all, while it is calculated to lay the foundation of such improvement in the arts, as we trust will raise Britain even to a higher rank that she has yet held among the nations.

In the *Observer*, the following appeared on the 16th of May, 1813.

> *Genius, like Egypt's Monarchs, timely wise,*
> *Constructs its own memorial ere it dies.*

Never has it fallen to the lot of genius in this country, to be so highly honoured, as in the person of Sir Joshua Reynolds. Surrounded and

admired during a long life, by all that was splendid in opulence, all that was dignified in rank, all that was lovely in beauty, all that was powerful in talents, all that was estimable in virtue — his death was universally held to be a national calamity, an unexampled respect was paid to his memory, he was followed to the grave by the most noble and distinguished individuals in the land, and the metropolis assumed an exterior of grief, which, until that period, had been reserved for Royalty alone.

The works of this great artist, diffused throughout the empire, have long been the delight of every one capable of appreciating excellence. The Governors of the British Institution, having conceived the magnificent idea of collecting a number of the most highly esteemed of those works, proceeded with that laudable ardour by which they have on so many occasions been actuated, to execute their intention; and the public were, on Monday last, admitted to witness the triumph of British art, which is the result of their exertions.

Language is inadequate to express the effect of this unprecedented assemblage of genuine splendour. That admiration which the sight of a single fine production of Sir Joshua's cannot but always

inspire, is here increased and sublimed till the mind is almost overwhelmed by its intensity. An awful and indescribable sensation — elevating conviction of the greatness of human powers mingled with melancholy reflection on the shortness of their duration — must be experienced by the beholder. But what will unquestionably be the ultimate and triumphant feeling of the generous and patriotic breast, is exultation that England has given birth to a painter of such exalted genius and such refined taste, a painter who, in immortalizing himself, has contributed with the kindred spirits of a *Shakespeare*, *Newton*, and a *Chatham*, to confer on his country that character by which alone a civilized and intellectual world is distinguished from a savage and barbarous nation.

The present Exhibition will forever set at rest the question which by some has been so strangely raised as to the competency of Sir Joshua Reynolds to the attainment of excellence in the highest department of art, had a corresponding disposition on the part of the public induced him to direct his studies to that object. No one can hesitate to pronounce in the affirmative, who contemplates the *Ugolino*, the *Cardinal Beaufort*, or the *Infant Jupiter*. Of his talents in compositions of a less dignified but more generally pleasing

nature, the *Infant Academy*, the *Robin Goodfellow*, and the *Gipsy Fortune-Teller*, afford most exquisite specimens. But the taste of the times in which Sir Joshua lived compelled him to devote himself principally to portrait painting; and the consequence was, that to that part of the art he imparted an elevation which it had never before enjoyed. Many of the finest of his performances of that description are in the British Gallery, and they exhibit the most profound knowledge of composition, colouring, and expression. Among the most prominent of these are the portraits of Dr. Johnson, Sterne, Goldsmith, Dr. Burney, the Marquis of Granby, Admiral Keppel, Mr. Whitbread, Mrs. Robinson, Lady Hamilton, Mr. Tomkins, Mr. Dunning, the Duke of Orleans, &c.

From the Morning Post, August 23rd, 1803.

CLOSE OF THE BRITISH GALLERY

Our attention and space were so completely occupied in the beginning of last week, with the record of the triumph of our Arms in the

Opposite: John Manners, Marquess Granby, 1763-65, British Commander in Chief during the Seven Years' War, shown at the Battle of Vellinghausen; the portrait was presented to the French general defeated at the battle

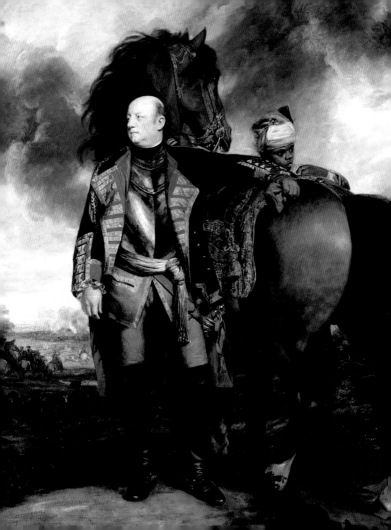

Peninsula, that we had not the good fortune to allot that portion of either which the subject merited, to notice this conclusion of one of the greatest triumphs of the *Arts*. But as a grateful duty can never be performed too late, we now seize an opportunity of discharging a debt which we owe to the public, having already called so repeatedly for this brilliant national exhibition.

Its objects, as detailed in the preface to the catalogue, which has been so widely diffused, as to render renumeration needless, are every way so admirable, as to challenge unmingled praise from the friends of the Arts. To advance the national character, to honour the memory of departed genius, and at the same time, to instruct and stimulate the living artist to a glorious competition, involved a design worthy of those who originated and matured this splendid idea. The two first of these points, no one will deny, the opening of this gallery has completely accomplished. Our national character in the art has been elevated above envious criticism — the memory of the estimable artist has been renewed and impressed on every mind with augmented force. It remains to be seen how far the third and last object will be attained; but we have no hesitation in pronouncing, that the young artist who remains unimproved by the

contemplation of this gallery of splendour, will never reach any eminence in his profession.

The study of these pictures, above that of the pictures of any painter that ever existed, furnishes a history of the art, and is calculated to convey instruction the most valuable. They embrace the whole space of a long life spent in anxious endeavours to attain perfection, especially in colouring — the most fascinating, if not the highest branch of the Art. The failure, in a few instances, conveyed as useful a lesson as the perfect success in others. Sir Joshua returned from Italy in 1752, and from that period to 1791, (he died, Feb. 23, 1792) he so applied his talents to the improvement of that profession to which he had done so much honour, as not only to acquire the highest fame, but to leave the art in a state of elevation which it had never before enjoyed in England, and achieve more than was ever achieved by any single artist in any age or country. A series of the productions of such a man must surely be full of interest to the public generally, and replete with information to the artist especially.

We do, therefore, look most confidently to see the benefits derived from this exhibition, displayed in many a future effort of native genius; and the more so, as in addition to the casual view of the whole number, in common with other

visitors to the gallery, we learn with pleasure that the following excellent pictures have been left by their liberal owners for the particular advantage of the students. They are admirable, — some of them the *chef d'œuvres* of *Reynolds*, and if profitably consulted, will, we trust, lay the foundation of future greatness so acknowledged, as to create the originals no mean rivals, and to the country no unworthy ornaments:—

Pictures.	*Proprietors.*
Portrait of the Duke of Orleans	The Prince Regent
,, Sir Joshua Reynolds	The Royal Academy
,, Mrs. Siddons.	Wm. Smith, Esq. M. P.
,, the late John Hunter, Esq.	Mrs. Hunter
,, Bishop Newton	Abp. of Canterbury
Death of Cardinal Beaufort	} Earl of Egremont.
Virgin and Child	
Infant Jupiter	Duke of Rutland
Infant Hercules	Lord Fitzwilliam
Infant Academy	Viscount Palmerston
Infant Samuel	Right Hon. Charles Long
Venus and Cupid	} Earl of Upper Ossory
Hope nursing Love	
Nymph and Child	Earl of Carysfort
Sleeping Child	Earl of Aylesford
Cupid and Psyche	} Samuel Rogers, Esq.
Sleeping Girl	
Theory of Painting	—— Hughes, Esq.

Opposite: Hope Nursing Love, 1771, mezzotint by Edward Fisher after Reynolds

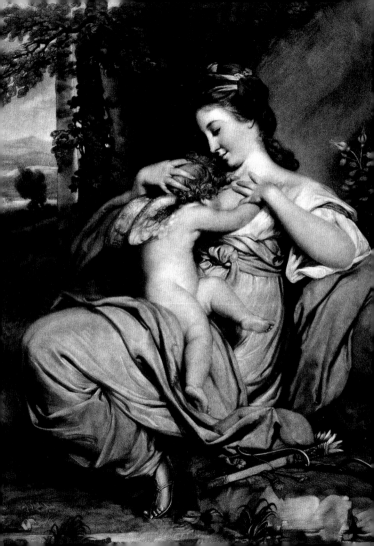

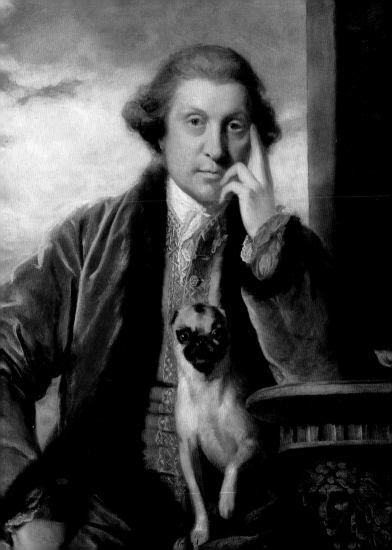

From the study of these, we doubt not, many a splendid work may hereafter be traced. As *Reynolds* drew the mastery evident in the heads of his portraits from Raphael, in the Vatican, so may our students acquire similar skill from him who has thus naturalised the splendours of *the Divine*, and made them British without impairing their superiority. As *Reynolds* added his own experiments in colouring to the tints he reaped from a close attention to the Venetian school, our students acquire similar skill by marking his productions, in which they are so pre-eminently combined. From him the painter of history may be inspired with taste — the portrait painter may be taught breadth and freedom of pencilling, richness of colouring and brilliancy of effect; the poetical painter delicacy, and every enchanting quality which can inhabit works of fancy; even the landscape painter may from his backgrounds receive no worthless hints, and all artists something which may convert to their manifest improvement.

All this we anticipate; but not only this, but an amended capacity in those who patronise and judge to enable them better to appreciate what shall be produced. Looking, then, to a golden age

Opposite: George Selwyn, 1766, society wit, satanist and necrophile, with one of his pugs, possibly Raton

for the art, with merit and encouragement, proceeding side by side, from the date of this truly admirable exhibition, we take our leave from that, the like of which we never may see again.

To these specimens many others might be added: — for the press poured forth its praise in every shape, and from every quarter; but what has been given will suffice to shew how much public feeling was excited by that memorable display of the works of our illustrious countryman.

Doubtless it was honourable to the memory of Sir Joshua Reynolds to have been thus made the subject of universal panegyric; and also to the country, that it should have been so liberal in its praise where it was so well deserved; but however satisfactory to observe the just and generous direction of popular opinion in this case, it must be evident to all who can appreciate the merits of public animadversion on such topics, that to admire, and even to have a strong feeling for works of elegant art, does not necessarily imply much critical skill in them.

In comparing Sir Joshua Reynolds with the greatest artists that ever lived; or, which was often done,

in preferring him to all, by supposing him to have united in himself whatever was admirable in each, there is an extravagance which destroys the value of praise, and gives it almost the effect of ridicule. There are, in fact, few of the many who undertake to be the guides of taste, that are equal to the task; so that although an artist may not be displeased to find his works commended, he has frequently, at such times, more cause to approve the kind *disposition* of his panegyrist, than to admit the arguments on which his encomiums are founded — indeed he is on that account often alarmed at the praise he hears, and thinks good fortune alone had preserved him from condemnation.

Nevertheless, perilous as it is to venture on critical ground, the course of this narrative now drawing to a close, requires some final remarks on the great and excellent character which is its subject.

The following description of Sir Joshua's person which has been given is exact: — 'In his stature, Sir Joshua Reynolds was rather under the middle size. He was in height nearly five feet six inches, of a florid complexion, roundish blunt features, and a lively pleasing aspect; not corpulent, though some-

what inclined to it, but extremely active.' With manners highly polished and agreeable, he possessed an uncommon flow of spirits, but always under the strictest regulation, which rendered him, at all times, a most pleasing and desirable companion. Such was the undeviating propriety of his deportment, that wherever he appeared, he, by his example, invariably gave a tone of decorum to the society. With a carriage the most unassuming, he always commanded that personal respect which was shewn him on all occasions. No man was more fitted for the seat of authority. When acting in a public capacity, he united dignity with ease; in private society, he was ever ready to be amused, and to contribute to the amusement of others; and was always attentive to receive information on every subject that presented itself; and by the aid of an ear-trumpet he was enabled to partake of the conversation of his friends with great facility and convenience. He was very observant of character; but if he made remarks upon singularity or vanity, it was with playful delicacy. On dispositions of a more offensive kind he seldom expressed his feelings, but guarded himself against obtrusive advances

Opposite: Nelly O'Brien, c. 1762-64. O'Brien was a well-known courtesan who was a close friend and possibly mistress of Reynolds. Her dress was originally crimson

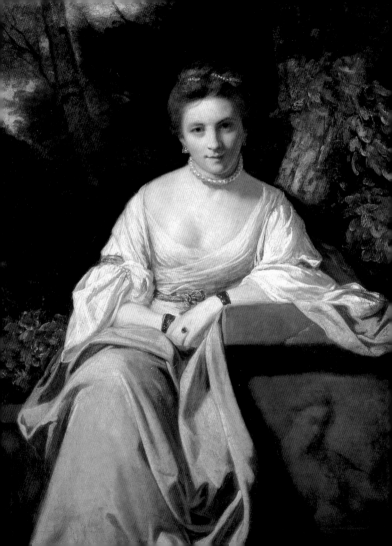

by gently shifting his attention to some other object. He was very easy of access, and the young artists who were desirous to benefit by this advice, found no difficulty in obtaining it, and it was always given frankly and kindly, with great sincerity, but with as much encouragement as truth would allow.

If it were asked, how Sir Joshua appeared to stand in his own opinion of himself, the answer would be, that he was an exemplary instance of modesty. To the compliments he received, he listened and bowed, but it was rather as one submitting to the remarks that were made, by which he might profit, than the complacency of self-approbation. He never justified the encomiums of admiring spectators of his works by reasoning upon them. Having performed what he undertook to do, he left to others to judge of the quality of his productions. He would occasionally notice some difficulty he had found in executing a work, to account for some questionable appearance, or to shew the necessity of sometimes trespassing a little upon truth, in order to satisfy the eye; but such remarks were only made to artists, and were always accompanied with a caution against the practice, except where indispensibly necessary. In painting, as in music, deviations from strict

rules are occasionally required; and to justify these, the artist can only refer to feelings which, to him, supply the place of laws. It is recorded in a late publication, that when Haydn, the celebrated musical composer, was requested to give his reasons for certain unusual transitions or modulations in his work, he merely answered, 'I did it because it was best so.'

In professional application Sir Joshua Reynolds, as before stated, was an extraordinary example of persevering industry. It has been justly observed, that 'he was never wearied into despondency by miscarriage, nor elated into neglect by success.' His art was always in his mind, and, as it was truly said,

> when the *man* went abroad, he did not leave the *painter* at home. All nature and all art was his Academy; and his mind was constantly awake, ever on the wing, comprehensive, vigorous, discriminating, and retentive. With taste to perceive all the varieties of the picturesque, judgment to select, and skill to combine what would serve his purpose, few have ever been empowered by nature to do more from the funds of his own genius, and none ever endeavoured more to take advantage of the labours of others, in making a splendid and useful collection, for which no

expense was spared; his house was filled to the remotest corners with casts from the antique, pictures, statues, drawings and prints, by the various masters of all the different schools and nations. Those he looked upon as his library, with this advantage, that they decorated at the same time that they instructed. They claimed his constant attention, objects at once of amusement, of study, and of competition.

In portrait painting, the general demands upon composition are so limited, and its rules may be applied with such laxity, that it affords the artist but little exercise to prepare him for higher exertions; and therefore, whatever his natural talents, the painter of extensive practice in that line, must in respect to original composition, be liable to those dangers of inactivity so judiciously pointed out in the discourses of the President himself.

This, in fact, was precisely his own situation. He was not called upon by the regular habits of his practice for any extensive exercise of his creative powers, and consequently, he was not ready and expert either in inventing or combining the requisite materials of historical art, whenever he ventured upon that department. This was, doubtless, the cause that he

did not sufficiently assert the independence of his own genius, and that he consented, perhaps too easily, to accept assistance from the conceptions of others; but to the hints he thus occasionally borrowed, it must be acknowledged, he always gave such an air of novelty, and applied them to his own purposes with such admirable skill, that they often acquired a value they did not before possess; and his compilations had almost as much originality as if nature and the resources of his own mind had supplied every part.

Yet this deficiency must have been the source of innumerable difficulties and impediments in every large work, and, no doubt, deterred him from many a lofty undertaking to which an active imagination would be continually inviting him. But though he could not attempt to rival Michelangelo and Raphael in their elevated line, from what he has accomplished in his own way, he will be ranked with the most distinguished geniuses who have adorned the art. The world, in truth, scarcely knew the fascinations of colour, in its most impressive combinations with light and shade, till the works of Reynolds had been seen. Even to historical subjects, in many instances, he gave a charm that was before unknown. His *Ugolino* is an eminent example of

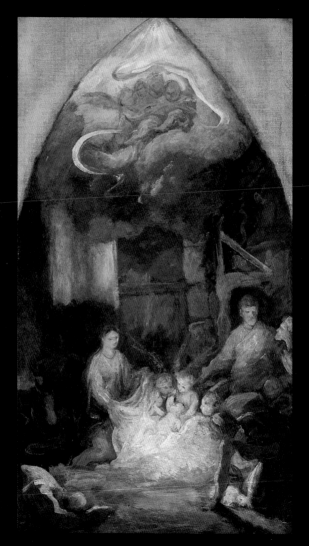

pathos and force of expression, to which his excellent management of colour, and light, and shade, greatly contributed. His picture of the *Nativity* had all the splendour and harmony that colour could give; but these qualities were applied to that grave but simple subject with so much judgment and feeling, that the whole appeared a scene of holy mystery; nor could the imagination have been more powerfully affected, if the same scene had been illustrated by the forms of Michelangelo and Raphael.

From the frequency of his alterations in the progress of most of his larger works, it would appear that our great artist, although in his fine sense of colour, he was inferior to none of his predecessors, he had not attained the science of which the old masters were certainly in possession; but trusted rather to a spontaneous and momentary feeling than to any established principles. He had unquestionably many golden rules, many precious maxims floating in his mind, but he had not the time or the skill to give the treasures of his taste and experience

Opposite: Sketch for the Nativity, 1777; the painting, which was used for windows in the chapel of New College Oxford, was lost in a fire. The sketch was once owned by Sir Thomas Lawrence

a systematical form, so as to be able to bring them into use whenever they were required.

Thus, from the fortuitous nature of his practice, his works were liable to inequality. Proceeding without those guides which alone could secure to him the full result of the great powers which nature had given him, and never contented to repeat what he had happily done before, every picture was an experiment on some project of improvement suggested by his incessant endeavours to reach something yet unattained either by himself or others.

The great practice and indefatigable industry of Sir Joshua gave him an extraordinary facility of execution. His pencil was never mannered, but free, easy, and varied. His touch gave life and character; it had something magical in it: expressing the form intended without the least appearance of labour, and leaving no marks of a mechanical process; so that in copying his pictures, it is impossible to trace either the mode of producing them, or the stages of their progress.

It has been frequently questioned whether, in his discourses, his high encomiums on the sublime

works of Michelangelo, and Raphael, did not pro-
ceed less from the heart than from a compliance
with established opinion; and from an apprehension,
that without such a declaration, it might be supposed
his mind did not expand to more elevated conceptions
of his art than was manifested in his own practice; that
for the purpose of standing high as a critic, the judg-
ment he gave was rather affected than sincere; and
that he was desirous to appear foremost in supporting
an opinion which ages had sanctioned. His critical
theory, it has been said, was nearly in all points in
direct opposition to his practice. Some have thought it
impossible for one whose whole mind had been
throughout a long life, engrossed in the study of what
he properly called the ornamental style of painting
could be capable of feeling the profound veneration
which, in so marked a manner, he expressed for the
works of Michelangelo: and that he should almost
treat with contempt, the line of art to which he had
devoted himself: for after having in his discourses dis-
criminated the grand from the subordinate style, and
asserted that the pretensions of the latter to the name
of painting, are just what the epigrammatist and son-
neteer have to the title of poet, he says, 'in the same
rank, or perhaps lower, is the cold painter of portraits.'

It does not appear that any thing growing out of this comparison proves Sir Joshua to have been inconsistent; on the contrary, it would seem that this judgment was the result of a just estimate of the art by one who saw it in its utmost compass, and felt the high claim, which, when carried to its utmost elevation, it has to be classed with those efforts of the human mind that do most honour to our nature. Viewing the great question of comparative excellence in this light, Sir Joshua made his parallel, and its truth is felt. He is not to be deprived of the right of admiring that which he did not attempt to imitate, and for which the many circumstances already stated concurred to make success hopeless. In the chair of the Academy, professing to give public instruction to the youth of the country, whose minds were directed to the arts, he performed his duty upon an extended principle: not allowing his own particular taste or practice to narrow the proper view of the subject. The sincerity with which he delivered his thoughts may be deemed unquestionable; for supposing that there was really something like vanity in appearing to hold the opinions he maintained, it is certain, even upon that ground, he felt assured that he was supporting those doctrines which he believed were best founded and would

be most lasting. But, as before observed, Sir Joshua had a large mind which could contemplate with profound admiration the highest efforts in art, and could feel delight also in ingenuity shown in the humblest walk. He bowed before the mighty powers of Michelangelo; and had pleasure in considering the laboured skill of Van der Heyden.

It has been said, that, for this dereliction of his professed theory, in declining to pursue the study he so strongly recommended to others, he has, when it was hinted to him, been heard to make two excuses: first, 'that he adapted his style to the taste of his age.' The reply to this was, 'but ought not a great man, placed at the head of the art, to endeavour to lead and improve the taste of the public, instead of being led and corrupted by it?' His second excuse was, 'that a man does not always do what he would, but what he can.' To which it was answered, 'This, whatever truth there may be in it, comes with an ill grace from one who constantly and confidently maintained in his writings, that by exertion alone every excellence, of whatever kind, even taste,and genius itself might be acquired.' The same critic proceeds to say,

the fact is, perhaps, that he never truly felt the excellencies of the grand style, of which his disappointment at the first sight of the works of Raphael in the Vatican, in addition to his violent opposition to it in his practice, is a strong proof. He wrote from his head, but he painted from his heart; and the world loses nothing by his not having had an opportunity of putting his resolution in practice, of adopting the style of Michelangelo, could he have been permitted to begin the world again; a declaration made without a proper appreciation of his powers, which do not at all appear to have been calculated for excelling in the grand style.'

These remarks, which are specious, are nevertheless uncandid, and inapplicable.

What has been stated of Sir Joshua's progress in his art, will, it is hoped, be sufficient to show, that there is no just ground to charge him with inconsistency. It appears that the author of these criticisms had paid little attention to his history. To make such observations, on reasonable grounds, it should be supposed that Sir Joshua Reynolds, at the commencement of his studies, had a clear view of the extent to which the art had been carried, and that he

had established in his mind the principle, that, by exertion alone, every thing might be acquired. That he held this opinion is certain; but at what period was it formed? Not when he had a life to pass, and opportunity for proper study; but after the hours of his youth, the only time for due preparation, were gone, and he had arrived, according to human reckoning, at an age, when, as he observed, 'a man does not always do what he would, but what he can,' to reproach him with dereliction of his theory, is the height of injustice. However useful the advice he gave to others, it was not, under his circumstances, applicable to himself. It would have been folly in him to have attempted it. Sir Joshua formed his discourses for the instruction of youth, after long experience: having surveyed the art in all its extent and variety, and his advice was the result of deep philosophical thinking. Giving the whole of life to it, he believed every thing was attainable; but he points out the difficulties attending the study of art, and the necessity for unremitting, long-continued application. The principle he maintained was, that 'labour, well-directed, overcomes all things.'

Besides, though the style of Sir Joshua was necessarily ornamental, there was nothing in it that should

warrant the assertion that he was naturally incapable of a more elevated practice. His compositions are animated and sensible, and they moreover evince a strong perception of beauty, dignity, and grace; from these elements it seems probable that the grandest style might, with due cultivation, have been produced; but certainly the grandeur of Reynolds would have corresponded with the simplicity of his mind, which was devoted to nature and truth, and would have had nothing of that inflated character which is too often seen in vain attempts at sublimity.

The following letter, published with the works of the late James Barry, Esq. historical painter, contains advice so excellent, that it seems proper to be added to the other admirable lessons of instruction contained in these volumes. It appears to have been written early in the year 1769, at which time Mr. Barry was pursuing his studies at Rome, but, unfortunately, was much embroiled in disputes with his brother artists — a circumstance hinted at in the letter.

DEAR SIR,

I am very much obliged to you for your remembrance of me in your letter to Mr Burke, which, though I have read with great pleasure, as a

composition, I cannot help saying with some regret, to find that so great a portion of your attention has been engaged upon temporary matters, which might be so much more profitably employed upon what would stick by you through your whole life.

Whoever is resolved to excel in painting, or indeed any other art, must bring all his mind to bear on that one object, from the moment he rises till he goes to bed; the effect of every object that meet a painter's eye, may give him a lesson, provided his mind is calm, unembarrassed with other subjects, and open to instruction. This general attention, with other studies connected with the art, which must employ the artist in his closet, will be found sufficient to fill up life, if it was much longer than it is. Were I in your place, I would consider myself playing a great game, and never suffer the little malice and envy of my rivals to draw off my attention to the main object, which, if you pursue with a steady eye, it will not be in the power of all the Cicerones in the world to hurt you. Whilst they are endeavouring to prevent the gentlemen from employing the young artists, instead of injuring them, they are in my opinion doing them the greatest service. Whilst I was at Rome I was very little

employed by them, and that little I always considered as so much time lost; copying those ornamental pictures which the travelling gentlemen always bring home with them as furniture for their houses, is far from the best manner of a student spending his time. Whoever has great views, I would recommend to him whilst at Rome, rather to live on bread and water, than lose those advantages which he can never hope to enjoy a second time, and which he will find only in the Vatican, where, I will engage, no cavalier sends students to copy for him. I do not mean this as any reproach to the gentlemen; the works in that place, though they are the proper study of an artist, make but an awkward figure painted in oil, and reduced to the size of easel pictures. The Capella Sistina is the production of the greatest genius that ever was employed in the arts; it is worth considering by what principles that stupendous greatness of style is produced; and endeavouring to produce something of your own on those principles will be a more advantageous method of study, than copying the St. Cecilia in the Borghese, or the Herodias of Guido, which may be copied to eternity, without contributing one jot towards making a man an able painter.

If you neglect visiting the Vatican often, and

particularly the Capella Sistina, you will neglect receiving that peculiar advantage which Rome can give above all other cities in the world. In other places you will find casts from the antique, and capital pictures of the great painters, but it is there only that you can form an idea of the dignity of the art, as it is there only that you can see the works of Michelangelo and Raphael. If you should not relish them at first, which may probably be the case, as they have none of those qualities which are captivating at first sight, never cease looking till you feel something like inspiration come over you, till you think every other painter insipid in comparison, and to be admired only for petty excellencies.

I suppose you have heard of the establishment of a Royal Academy here; the first opportunity I will send you the discourse I delivered at its opening, which was the first of January. As I hope you will be hereafter one of our body, I wish you would, as opportunity offers, make memorandums of the regulations of the Academies that you may visit in your travels, to be engrafted on our own, if they should be found to be useful.

I am, with the greatest esteem,

Yours,

Joshua Reynolds

On reading my letter over, I think it requires some apology for the blunt appearance of a dictatorial style in which I have obtruded my advice. I am forced to write in a great hurry, and have little time for polishing my style.

A List of the Number of Pictures Exhibited by Sir Joshua Reynolds; with the Years in which they were exhibited.

The first Exhibition was in 1760, at the Great Room belonging to the Society, instituted for the Encouragement of Arts, Manufactures, and Commerce.

1760 Mr. Reynolds sent 4 Pictures.

The following year, viz. 1761, the Artists exhibited at the Great Room in Spring Gardens.

1761 Mr. Reynolds sent 5 Pictures. { One of them was a portrait of the Rev. Laurence Sterne, the celebrated author.

1762 - - 3 ditto. { One of them, Mr. Garrick between Tragedy and Comedy.

1763 - - 4 ditto.
1764 - - 2 ditto.
1765 - - 2 ditto. { One of them a whole length of Lady Sarah Bunbury, sacrificing to the Graces.

1766 - - 4 ditto.
1767 - - ————
1768 - - 1

And at an Exhibition made for the King of Denmark } 4 ditto
————

25

The Royal Academy having been instituted in 1768, and Mr. Reynolds elected President of the Society, he from that time exhibited at the Royal Academy only.

1769 Mr. Reynolds sent 4 Pictures.
1770 - - 8 ditto.
1771 - - 6 ditto.
1772 - - 6 ditto.

1773 - - 12 ditto. { Including whole-length portraits of the Duke and Duchess of Cumberland.

1774 - - 13 ditto. { Including the Duchess of Gloucester and the Princess Sophia; also the Marchioness Townshend and her Sisters, Mrs. Gardiner, and Mrs. Beresford, decorating the altar of Hymen; also his first *Infant Jupiter.*

1775 - - 12 ditto. { Including Mrs. Sheridan, as St. Cecilia.

1776 - - 12 ditto. { Including Omiah, and Master Crewe as Henry VIII.

1777 - - 13 ditto. { Including the *Fortune Teller.*

1778 - - 4 ditto. { Including the *Nativity.* This fine work of art was unfortunately destroyed by fire at Belvoir Castle (the Duke of Rutland's).

1779 - - 11 ditto.

1780	-	-	6 ditto.	Including the *Death of Dido*, and portraits of the Three Ladies Waldegrave.
1781	-	-	8 ditto.	
1782	-	-	13 ditto.	
1783	-	-	10 ditto.	Including the Prince of Wales, and Col. St. Leger; his fine whole-length of Mrs. Siddons; and a portrait of the Right Hon. Charles Fox.
1784	-	-	14 ditto.	
1785	-	-	15 ditto.	
1786	-	-	12 ditto.	Including a whole length portrait of the Duke of Orleans.
1787	-	-	12 ditto.	Including the Prince of Wales, &c.
1788	-	-	18 ditto.	Including *Hercules*, the picture painted for the Empress Catharine.
1789	-	-	12 ditto.	Including the *Continence of Scipio*, *Cymon and Iphigenia*, *Cupid and Psyche*, and *Robin Goodfellow*.
1790	The last year of his exhibiting		17 ditto.	Including Mrs. Billington, the *Singer*, &c.

$$\overline{228}$$

Total, -	At the Room of the Society of Arts,		4
	At the Room in Spring Gardens		- 20
	At the Royal Academy	- -	228
		Total	252

Mr. Malone has mentioned the Collection of Pictures by ancient masters, belonging to Sir Joshua Reynolds, was in March, 1795, sold by auction for -	£10,319	2s	6d
And in April, 1796, various historical and fancy pieces of his own painting, together with some unclaimed portraits, for	£4,505	18s	0d
To which may be added, that his Collection of Drawings and Prints was sold by auction in March, 1798, for -	£1,903	0s	0d
	£16,728	0s	6d

NOTE TO P. 51 Signior Marchi being thus noticed, some account of him may not be unacceptable. Marchi's talents as an artist were naturally not brilliant, and his progress was inconsiderable. He was nevertheless a man of sense and perfect integrity, and from the excellence of his temper, and simplicity of his character, was universally beloved and respected. From the time of his first engagement till about the year 1770, he continued with Reynolds, who had for several years remunerated his services; but thinking that he might be able to obtain larger emolument in another situation, Marchi began to practise in London on his own account; but being induced by some friendly offers of employment in South Wales, he shortly left the metropolis, and resided in or near Swansea in Glamorganshire. His encouragement in this place failing after remaining several years, it became necessary for him to remove.

Accordingly Marchi returned to London, where, in his independent state, being still unsuccessful, he was induced to return to the service of his old master. Sir Joshua having offered to receive him on his former footing, Marchi willingly consented; and thus, after an interval of thirteen or fourteen years, he resumed a situation which he did not quit till the death of that great artist. The just principles and amiable qualities of Marchi were fully impressed on the mind of Reynolds, who, when speaking of the return of his pupils, strongly

expressed his feeling of Marchi's character; 'It was the dove,' said he, 'returning to the ark.' Joseph Marchi survived his master several years, having by prudent economy saved a sufficiency for his decent support during the remainder of his life. He died in London, April 2nd, 1808.

NOTE TO P. 55 The progress of Mr. Astley through life was remarkable. He was born at Wem, in Shropshire. His father was an apothecary. He was a tall, showy man, and had some talent in his profession. He had high animal spirits, which inclined him to dissipation. After his return from the continent he continued to paint portraits in London and in Dublin, and acquired some money by his pencil. Passing through Cheshire on his way back from Ireland, he visited the Knutsford assembly there. Lady Daniell, widow of Sir Thomas Duckenfield Daniell, happened to be present, and was at once so captivated by his person and deportment, that she contrived to sit to him for her portrait. She was at that time said to be in treaty of marriage with the Honourable John Smith Barry; but being somewhat piqued at what she thought inattention on his part, she told her story to Astley, and put it to him as a question, 'Whether, if under such circumstances, he could submit to be so neglected?' Astley was in rapture at the supposition of being in such a situation, and expressed

himself in terms so ardent that she offered him her hand.

By marriage articles, Lady Daniell reserved her fortune to herself; but Astley's behaviour was so satisfactory to her, that she soon gave him a portion of her property, and dying shortly after, settled upon him the whole of the Duckenfield estate (at that time estimated at £5,000 per annum) after the death, of her daughter by Sir William Daniell.

Mr. Astley, after the death of his lady, who was his senior, lived so expensively that in a few years his circumstances were much reduced, and he commenced a treaty for a *post obit* of the whole of Lady Daniell's property in succession to her daughter's life. His good fortune still continued. Unexpectedly the daughter of Lady Daniell died, which information he received the evening before the day on which the treaty was to have been completed, and Astley became possessed of the whole property. He continued a widower for several years, when, far advanced in life, he married a third wife, a young lady by whom he had two sons and two daughters. He died at his house, Duckenfield Lodge, in Cheshire, Nov. 14th, 1787.

Some further particulars respecting this favourite of fortune may afford matter for reflection. It is not uncommon to see, in instances of wasteful and even ruinous extravagance, that the inherent disposition of

the mind has been in direct opposition to it; and that while the dominion of ungoverned wishes has been at its height, selfishness, the latent propensity, has shown itself, and been mixed with dissolute prodigality: a fact strikingly verified in the subject of this anecdote. It was calculated that Astley wasted not less than one hundred and forty thousand pounds; yet such was the amount of the fortune he received, that at his death he left considerable property to his family. In his last years, it was said the state of his affairs affected his mind, and contributed to break up his constitution. He was at last reduced to great mental imbecility, but the natural propensity still predominated, and he laboured under perpetual apprehension of poverty. When these circumstances were related to Sir Joshua Reynolds, who was a great observer of character, he confirmed what had been said, of Astley's selfish disposition, and enumerated several of his contrivances to free himself from expence at the cost of others even in the height of affluence.

NOTE TO P. 84 Robert Strange was born in the Island of Pomona, in Orkney, July 14, 1721, and learnt the rudiments of his art from a Mr. Cooper of Edinburgh. When out of his apprenticeship he came to London, and was patronised by the Earl of Bute, by whose means he became particularly noticed by His present Majesty, then Prince of Wales. As an historical

engraver, he was even then superior to any of his contemporaries; but his laudable ambition for improvement, and attachment to his profession, determined him to undertake a journey to Italy, a circumstance which produced a misunderstanding between him and Lord Bute, who wanted him to engrave whole-length portraits of the Prince and himself, from pictures by Ramsay. Having subsequently experienced much coldness from Lord Bute, Mr. Strange believed that the mind of His Majesty was prejudiced against him in consequence of what he supposed to be misrepresentations of his conduct; and in a letter he published in 1775 addressed to Lord Bute, he complained of unhandsome treatment from an agent employed to collect works of art for His Majesty, which letter was prefixed to an *Enquiry into the Rise, &c. of the Royal Academy*, published by him at that time. But it may be supposed, that this and many other of his misapprehensions were eventually done away: for on the death of Prince Octavius, a favourite child of His Majesty, Mr. West painted the apotheosis of the Royal infant, and from this picture Mr. Strange made an engraving, which was much approved by the King, whose satisfaction and favour were sufficiently manifest by his conferring upon him the honour of knighthood in 1787. Sir Robert Strange died July 5th, 1792, at his house in Great Queen Street, Lincoln's Inn Fields.

NOTE TO P. 90 This notice of the great change in public manners and habits, naturally produces a vivid recollection of some curious and extraordinary inconsistencies that prevailed even in the highest ranks of society.

It has been thought, that attention to personal appearance has a moral good effect in tending to self-respect; there is, however, proof sufficient that though advantageous on many accounts, it contributes but little to elevate the mind, to a sentiment corresponding with such studied care of outward show. One of the characteristics of the last age was splendour of dress in the higher orders, which was imitated throughout the subordinate classes of society, as far as circumstances would allow. With this ostentation, there was much ceremony on public occasions; and in private intercourse, a proportion of it was observed. The different orders of citizens were rigidly separated by a high carriage on the one part, and a careful forbearance on the other; yet with all this apparent show and polish much brutality was mingled, and great and general licentiousness pervaded all the ranks of the community!

Hogarth, in depicting the character and manners of his day, has shown in various of his scenes, that vice and debauchery triumphed everywhere, not in secrecy and concealment, but in the most open manner. The high-dressed beau and the low libertine were similar in profligate indulgence. Licentious conversation commonly

made part, often the greatest part of the amusement at the dinner-table, where hospitality usually ended in extreme intemperance. Such were the manners of the people in little more than half a century ago.

The great change that has been since effected in the different relations of social life is conspicuous and gratifying. This incongruous mixture of moral laxity and external restraint has been succeeded by a state of society more rational and more refined. Convivial intemperance is no longer the prevailing fashion of our social meetings; and the current of familiar conversation is purified from the taint of indecency.

If other evidence were wanting, an obvious proof of this great moral amendment is to be found in the actual state of the drama. The productions of our later dramatists are free from the shameless grossness that too frequently debased the wit of their predecessors, and has left a stigma on the character of the age that could tolerate it. Within the same period, the formalities of etiquette and dress have been materially relaxed; perfect freedom of manners has been reconciled with perfect decorum; and the orders of society have been blended, and the distinctions of rank gradually softened by an easy, unrestrained intercourse.

It would not be difficult to show that the general reformation of mind and manners has not confined itself to the circles of private life; but in union with public

spirit, it has displayed itself in the foundation of numerous societies for the diffusion of knowledge, and the cultivation of industry, the relieving the distresses, and, correcting the vices incident to human nature.

In the benefits derived from the improved state of society, the Fine Arts have largely participated. They may, perhaps, be said to have, in some degree, contributed their assistance to the great work of moral reform, inasmuch as the direction which productions of art give to the public mind tends to refine as well as to amuse. The Royal Academy and the British Institution — establishments originating in the patriotic exertions of private individuals — have received the sanction of royal patronage, and the reward of public favour and encouragement.

Thus those Arts which are calculated to aid and illustrate religion and morality; to gratify the feelings of affection, by preserving the images of love and attachment; to display the beauties of nature in all her variety; and to embellish and ornament a great country, are now cherished with a liberal regard to their value.

NOTE TO P. 105 John Boydell was born in Dorington, near Ower in Shropshire, January 19, 1719. His grandfather was the Rev. John Boydell, D. D. vicar of Ashbourne, and rector of Mapleton in Derbyshire. His son, Josiah, the father of John Boydell, was a land

surveyor, and intended to bring up his son for his own profession; but while John Boydell was occupied in this, pursuit, he was first stimulated to attempt drawing and engraving as a profession, from seeing the drawings of Mr. Baddesley, who made views of gentlemen's houses, from which engravings were made by Wm. Henry Toms. This inclination became so strong, that when 21 years old he resolved to become an engraver, and with that spirit and perseverance which he manifested throughout his life. In 1741 he left his father's house at Harwarden in Flintshire, and walked up to the metropolis, and bound himself apprentice for seven years to Mr. Toms, the engraver of the print which had so forcibly attracted his attention. After steadily pursuing his business for six years, and finding himself a better artist than his teacher, he bought from Mr. Toms the last year of his apprenticeship, and became his own master. In 1745 or 1746, he published six small landscapes designed and engraved by himself. He proceeded with unabating industry to engrave and publish till he had completed one hundred and fifty-two prints, which he collected in one volume, and published it at five guineas. With the profits of this volume, he was enabled to pay the best Artists of his time, and thus presented the world with English engravings from the works of the greatest masters. The encouragement he experienced from the public was equal to the spirit and

patriotism of the undertaking, and soon laid the foundation of an ample fortune. He used to observe, that he believed the book we have alluded to was the first that ever made a Lord Mayor of London, and that when the smallness of the work was compared with what had followed, it would impress all young men with the truth of what he had often held out to them, 'that industry, patience, and perseverance, if united to moderate talents, are certain to surmount all difficulties.' On the 5th of August, 1782, Mr. Boydell was chosen Alderman of London, for the Ward of Cheap. In 1785, he served the office of Sheriff; and in 1790 was chosen Lord Mayor of London, an office of which he discharged the duties and the honours with, a diligence, uprightness, and liberality, that may be equalled, but will rarely be exceeded.

After having expended in his favourite plan of advancing the fine arts in England no less a sum than 350,000 *l.*, this worthy and venerable character was necessitated, by the stoppage of his foreign trade during a dozen years of war, to apply to Parliament, in the beginning of 1804, for permission to dispose of the Shakespeare gallery, and his other collections of pictures and prints, by way of lottery. The act of Parliament being passed to sanction this lottery, the worthy Alderman had the gratification of living to see every ticket sold.

Mr. Boydell's death was occasioned at last by a too

scrupulous attention to his official duties. Always early in his attendance on public business, he arrived at the Sessions House in the Old Bailey, on Friday, the 7th of December, 1804, before any of the other magistrates, and before the fires were lighted. Standing near a grate while this was done, the damps were drawn out, and he took cold: this produced an inflammation of the lungs, which terminated his life on the Tuesday following, when he had almost completed the 86th year of his age. It may be truly said of this excellent man, that throughout his life, all his views were directed to benefit his country. He was sincerely religious, and unabating in his endeavours to improve the morals of the people. He had a tender heart, and in his administration of justice, though inflexibly just, he was constitutionally merciful; and when cases of dispute came before him, he laboured to restore peace and reconciliation. With respect to his property, he had no selfish views. The accumulation of wealth was to him an object only as it enabled him to carry his useful plans into execution, all other considerations of its value were secondary to this great purpose. The author of this narrative, who knew him well, has high gratification in recording this tribute to his virtues.

Illustrations

Cover: Self-portrait, *c.* 1788 © Royal Collection; an engraving
was used as a frontispiece for the edition of *The Literary Works
of Sir Joshua Reynolds*, of which Farington's *Memoirs* were part
p. 1 & p. 9 Self-portrait, *c.* 1747-48 © National Portrait Gallery
p. 2 Master Crewe as Henry VIII, *c.* 1775, private collection
p. 4 Self-portrait, *c.* 1779-80 © Royal Academy of Arts
p. 10 Page from a notebook carried on the Italian journey
© British Museum, courtesy of the Paul Mellon Centre for
British Art, London
p. 14 Georgiana, Duchess of Devonshire and her daughter,
Lady Georgiana Cavendish, 1784, © Trustees of the
Chatsworth Settlement, Chatsworth
p. 17 Mrs. Hester Lynch Thrale with her daughter
Hester Maria, 1777-78,
Beaverbrook Art Gallery, New Brunswick
p. 18 Omai, *c.* 1776, private collection
p. 21 Charles, 3rd Duke of Richmond, *c.* 1758
© The Trustees of the Goodwood Collection,
Goodwood House, Chichester
p. 22 Mary, Duchess of Richmond, 1764-67
© The Trustees of the Goodwood Collection,
Goodwood House, Chichester
p. 26 Augustus Hervey, 3rd Earl of Bristol, 1762,
courtesy of St Edmundsbury Borough Council,
Manor House Museum
p. 29 Plympton, etching by Lititia Byrne after
Joseph Farington, *c.* 1819

p. 175 'Perdita' (Mrs. Robinson), 1783-84
© Wallace Collection
p. 178 'Simplicity' (Theophilia Gwatkin) *c.* 1785
© National Trust, Waddesdon Manor
p. 182 Master Bunbury, 1781 © Philadelphia Museum of Art,
John H. McFadden Collection
p. 186 The Ladies Waldegrave, 1780-81
© National Gallery of Scotland
p. 193 John Manners, Marquess Granby, 1763-65
© John and Mable Ringling Museum of Art, Sarasota,
The State Art Museum of Florida
p. 196 Hope nursing Love, 1771, Edward Fisher after Reynolds
© British Museum
p. 197 George Selwyn, 1766, private collection
p. 202 Nelly O'Brien, *c.* 1762-64
© Hunterian Museum and Art Gallery,
University of Glasgow
p. 208 Sketch for The Nativity, 1777, private collection

Illustration on pp. 66 courtesy of Bridgeman Picture Library.
Others as noted
Illustrations on cover and pp. 2, 18, 26, 40, 76, 94, 98, 101, 109,
117, 130, 133, 139, 144, 148, 154, 168, 186, 196, 197, 202
with thanks to Dr. Martin Postle and to Tate Publications

The Publisher would like to record his gratitude
for the generosity of the many private collectors
whose pictures are reproduced here

First published 1819
This edition first published 2005 by
Pallas Athene,
42 Spencer Rise,
London NW5 1AP
www.pallasathene.co.uk
© Pallas Athene 2005

ISBN 1 84368 001 7

Special thanks to Martin Postle, Rebecca Fortey, Emma Woodiwiss,
Barbara Fyjis-Walker, Phil Kelly, Clair O'Leary
and Richard Humphreys

Textual Note:

The text of the *Memoirs* is taken from the first edition,
which Farington published in 1819
as part of the fifth, corrected, edition of
The Literary Works of Sir Joshua Reynolds, Kt.,
which also contained the less reliable
account of the painter's life
by his executor
Edmond Malone
Spelling and punctuation have been
very lightly modernized